FIRST EXPOSURES

STUDENTS

Dijorn Cole

Ai Mei (aka Jada) Ma

Marcio Ramirez

Karen Gochez

Bethany Castro

Jason Gershow

Daniella Espinoza

Jontonnette Clark

Jennifer Murcia

Jeremy Castro

Ivan Fernandez

Naomi Castro

Robert Lima

Franchesca Hernandez

Stanley Wong

Melanie Solis

SF Camerawork's programs are supported by The National Endowment for the Arts, Grants for the Arts of the San Francisco Hotel Tax Fund, San Francisco Arts Commission, The Andy Warhol Foundation for the Visual Arts, Comer Foundation, Fleishhacker Foundation, Gould Family Foundation, The Junior League of San Francisco, LEF Foundation, Louis R. Lurie Foundation, McKesson, The Nelson Fund of the Community Foundation Silicon Valley, Bernard Osher Foundation, Joseph R. Parker Foundation, Potrero Nuevo Fund of the Tides Foundation, The San Francisco Foundation, Stuart Foundation, Morris Stulsaft Foundation, Thendara Foundation, Zellerbach Family Fund, The Marnie Gillett Curatorial Fund, Camerawork's members and individual contributors.

SF CAMERAWORK

357 Mission Street, #200
San Francisco, CA 94105
Phone: 415.512.2020

sfcamera@sfcamerawork.org
www.sfcamerawork.org

First Exposures is published by SAN FRANCISCO CAMERAWORK, INC., a non-profit organization, in association with Rock Out Books,
www.rockoutbooks.com.

ISBN: 0-9762747-8-7.
Library of Congress Control Number: 2006928671

SF CAMERAWORK STAFF

Sharon Tanenbaum, Executive Director
Chuck Mobley, Associate Director
Casey Burchby, Development Director
Erik Auerbach, Education Coordinator
Cassie Riger, Gallery Manager
Andrew Goodrich, Gallery Assistant
Chris McCaw, Preparator

BOARD OF DIRECTORS

RJ Muna, President
Michelle Blakeley, Vice President
Ivan Vera, Secretary
Steven Blumenkranz, Treasurer
Charlotte V. Ero, Assistant Treasurer

Holly Baxter	Lisa Herrell	Alexander Lloyd
J.D. Beltan	Heather Kessinger	Trena Noval
Sarah Berg	Paul Klein	Heather Snider
Laurie Blavin	Jeff Leifer	Tabitha Soren
Dore Bowen	Paula Levine	Kirsten Wolfe
Jennifer Gonzalez	Michael Light	Michael B. Woolsey

PRODUCTION NOTES

Editor: Erik Auerbach
Book Design: Anthony Laurino
Photo Editors: Erik Auerbach and Jamie Lloyd
Copy Editors: Mark Chambers and Chuck Mobley
Editorial Assistance: Whitney Grace and Jennifer O'Keefe
Archival Research: Leah Holt, Tessa Hite, and Jennifer O'Keefe
Book Production: Rock Out Books
Project Management: Jay Blakesberg
Digital Production: Paul Halmos
Printing: Oceanic Graphic Printing, Inc.

PRINTED IN CHINA

Cover Image: Franchesca Hernandez, 2005

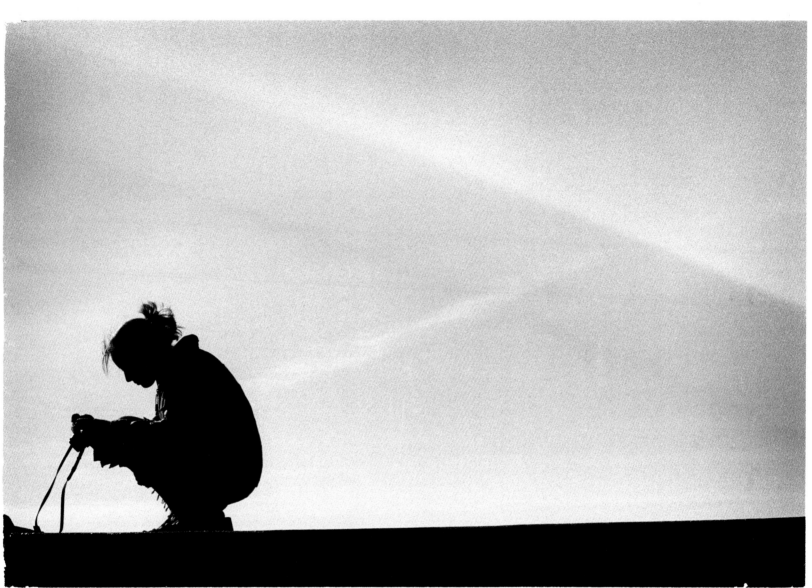

Bathany Castro, 2003

"My camera is my third eye, First Exposures is my second home, photography—my first love." —*Dijorn Cole, age 15, spring 2006*

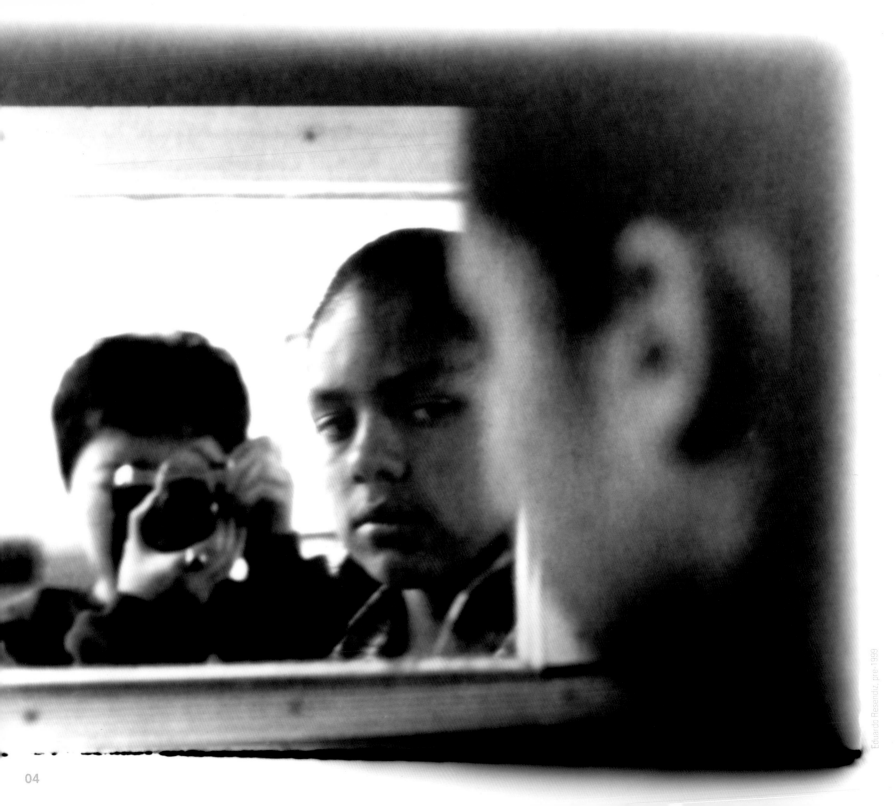

It might not be a term commonly used just yet, but arts mentorship is what First Exposures is doing, and it's a concept that works, and it's a concept that needs as much support as possible. Arts mentoring programs do something fairly simple: they make it possible for so-called at-risk youth to learn an art or craft, and to work directly with professionals working in that field. It sounds easy enough, and the great thing is, with a little bit of funding, it is easy enough. And the results are usually pretty spectacular. This book is a very good example of just how good work by younger artists can be if they're given the tools and some guidance.

We should back up for a second and talk about the context within which a program like First Exposures exists. First of all, it should go without saying that there are very few, if any, public high schools in San Francisco that have photography departments. Maintaining such a program is expensive, and certainly isn't a priority when teachers and administrators have to worry about test scores and core curriculum. In fact, arts programs in general are fairly scarce in public high schools, in this city and all over the country. We all know that the arts are the first to be cut when budgets are slashed or curriculums reprioritized. Many public schools don't have a school newspaper, a literary magazine, or even a band or orchestra.

So the main experiences these students are offered are core academics and athletics. But what happens to the students who have talent in the arts? In most cases they're left to fend for themselves elsewhere. Do these kids have the money to spend on private classes? It's debatable. So, wherever they can, nonprofit arts programs attempt to fill the gap. They do their best, though in most cases they can only reach a fraction of the kids who would benefit from their work.

The suburb where I grew up had well-funded public schools, but I should mention that as a high school sophomore, I was angry, confused, and covered in acne, and it was the arts that brought me out of a howling vortex of teenage angst. I liked to draw and write and take pictures, and this is the primary area where I felt valued. So I took art classes, photography classes, joined the literary magazine and newspaper and yearbook. In these contexts, I was heard and empowered.

When I was 13, I bought a Pentax K1000 with money earned cutting lawns over the summer. I loved that camera. The local college let me and a friend use their darkroom, and we spent hundreds of hours there, printing, burning, dodging, experimenting. A camera is a tool of power and control. The person behind the camera can shape their reality—to make it more beautiful, more orderly, more sensical (or less so). For a teenager who might feel confused by their world, and even powerless against the things he or she doesn't like about their world, having the power to shape it, or even change it, through a camera's frame—this is an important thing.

First Exposures is doing all this—giving young people some control, an outlet, a filter. And the results speak for themselves. Through the pictures in this book, you'll learn as much about San Francisco as you could in reading the newspaper for months. You'll see a city that might be different from the one you know, or these students might have finally captured, for the first time, the city you live in. All because they were given cameras and some guidance. When they're given the chance to shape and show you their world, the world becomes that much more their own. And the stronger they feel, the more confident and a part of the creation of that world, the better off they are and we are.

Dave Eggers is the founder of 826 Valencia, a writing center for students ages 8–18.

THE LANGUAGE OF CONNECTION: A GROUP OF MANY BECOMES ONE

BY ERIK AUERBACH

In 1993 First Exposures was born from a group of concerned photographers working out of San Francisco's Eye Gallery who wanted to do something more with their photographic skills and give something back to their community. Based on the Shooting Back project in Washington, D.C., First Exposures aimed to pair homeless, foster, and at-risk youth with qualified adult mentors in order to teach them photography in a one-to-one setting. With this mission as a guide, First Exposures took on its own life and personality. But sadly, three years later the Eye Gallery closed, and like some of its students, First Exposures was homeless. Then in 1996 San Francisco Camerawork brought in First Exposures and created its own educational programming. For ten years the program has flourished and grown to become one of the nation's most respected art mentoring programs. Each year the students have been given the opportunity to work on a large-scale project, ranging from exhibitions in galleries and museums to 2004's critically acclaimed Billboard project.

Part of the mission of First Exposures is to give these young artists a chance to bring their work to a larger audience. That's why you're now holding this book. Over these past ten years with Camerawork, First Exposures students have created some astounding work with the able guidance of their mentors. Here, we celebrate not only this work, but also the unique underlying relationships forged between mentors and students throughout the artistic process. In these pages you will find not only the work of the sixteen students in the program this year, but also a glimpse of our rich past, including some of the earliest work created in the program's infancy while still at the Eye Gallery.

Perhaps the most important aspect of our lives is the relationships we have with family and loved ones. While these may not always be positive, they help to form who we are or, as is often the case, who we aren't. Creating further relationships, beyond family and loved ones, is what mentoring is all about. In First Exposures we use photography to foster our connection between mentor and student. But the program also provides a safe place to open an exploration of so many other relationships, including how we interact with others and how we interact with places and things, spirituality and art. The student/mentor relationship becomes the foundation upon which these students can begin to explore these myriad relationships, many of which the students are experiencing for the very first time.

For many, a relationship with a place can be just as important as one with a parent or mentor. Occasionally we go somewhere and the association that comes with that place will hold a power much more intense than a familial bond. For example, standing on the beach at sunset can bring an inner peace not often experienced within the family environment. When you need to achieve that certain feeling you will go to the beach, just like someone with religious beliefs will go to a church or temple or mosque to find that inner peace. To elaborate on the quote by student Dijorn Cole on page 3, First Exposures can often be a second home, and in many ways the physical space of First Exposures serves as another type of inspirational place in which students can find their own peace. It is these various types of relationships that the students were presented with as potential themes when we began work on this book.

We all find strength in different ways, and relationships are a vital part of maintaining strength. Our relationship with our families, friends, loved ones, a place, a song, a work of art, or a god can all give us different levels of strength and support. The relationships we create are just as valid as the relationships that find us. By this I mean that while our connections to parents and loved ones are vitally important, oftentimes those relationships let us down and sometimes they don't last—sometimes we find someone or some thing that won't let us down in a way that is special for us.

In many ways this is what First Exposures can be. It is more than a collection of individual students and their adult mentors; it's more than youth

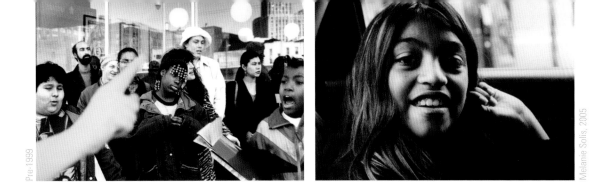

Pre-1999

Melanie Solis, 2005

learning photography. First Exposures is truly a collective entity, a group spirit, a team effort. It's the group feeling that makes our one-to-one mentoring special. When we operate as one unit we are huge. This group mentality is very much in line with the concept that "it takes a village to raise a child." In First Exposures it's the group interaction that really helps to foster creativity. There's nothing like watching a First Exposures class during a "photo share" or at lunch, when the distinctions between students and mentors blur a bit and we become just one big (usually) happy family.

As coordinator, I have strived to create an environment where First Exposures operates as a single entity. I see the team spirit as a way to nurture those who are a little behind, without holding back the more advanced photographers. When we show our students' work, it's about the whole group, not just one student or another. It's not a competition, but a means to grow—at whatever pace. In the fall of 2005 our students were invited to submit work to a contest at another non-profit gallery. Four of our students entered the contest, but only one was accepted to be in the show. Instead of bitterness or resentment, there was a resounding atmosphere of support for the accepted student. One of the students not selected said that it didn't matter if she won as long as First Exposures was represented.

As I look back at the archives from the past ten years and beyond, one thing becomes abundantly clear—given the right opportunities and guidance, the students of First Exposures have consistently created some amazing work, and this book is a real testament to that. One of the ideas of compiling this book was to elevate the work here to a more respectable and respectful level. Not wanting readers to view this book as merely "cute photos by kids," but rather as a real and valid anthology of work by First Exposures' young photographers, we aim to prove that a good picture is a good picture regardless of the age of the photographer. The talent displayed here is abundant, and many of these images might not have been possible for an adult to create. Many of the images and stories presented

here would fit easily into an art journal or literary magazine, and I am excited to be able to collect them all in this book for the first time.

Since its inception, First Exposures has been fortunate to have many amazing and talented photographers pass through its ranks—both as students and as mentors. Some of the mentors have gone on to pursue careers in art therapy, while others have been able to nurture their fine art or commercial careers to very successful levels. Some have even taken a cue from this organization to create their own programs including the Ghana Youth Photo Project (see p. 108) and other Bay Area–based programs built on First Exposures as a model. There are too many mentors to mention here by name—for that you will have to refer to the list on page 111. Unfortunately, in the course of putting this book together we discovered that it was nearly impossible to track down many of the former students due to their often transitory lives, their college careers, and the general instability of housing here in the Bay Area. We hope that this book will provide a bridge to make those connections with former students and mentors who once contributed to First Exposures, and we encourage all of them to be in touch.

As photographers and artists, we all hope that our images will find a sympathetic viewer, someone who will be able to identify with what we have created. All it takes is one person to relate to our work to help make that goal a success. It is this communicative power of our images that we strive for. As mentors we hope that we are able to help the students find that power and the ability to use it. They have all been given new skills to communicate and create some truly amazing art.

Erik Auerbach is the education coordinator at First Exposures. He has worked professionally in photography since 1985 and first began using a camera when he was eleven years old.

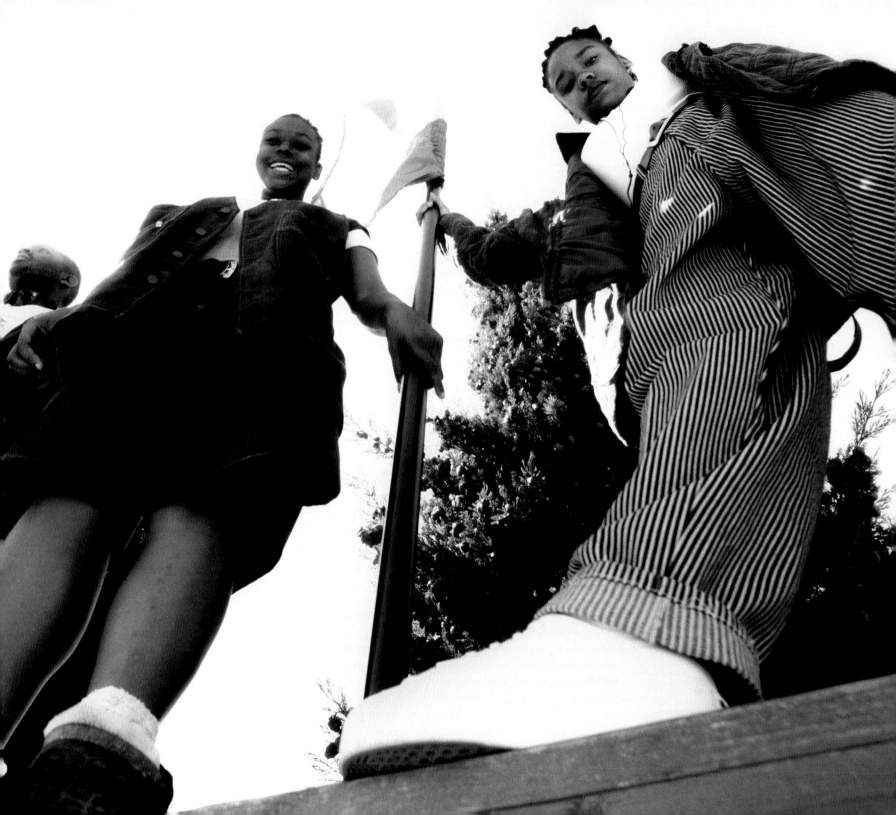

FIRST EXPOSURES:

THE REFLECTIVE ART OF MENTORING THROUGH PHOTOGRAPHY

BY MATT CARGES

Society needs to be shaken by the aspirations
of those who are not responsible.
—D. W. Winnicott[1]

There's no real teen equivalent to the toddler's plaster handprint, a loving display of the quickly growing body sentimentally fossilized by and for parents. During adolescence—no less a time of shutter-quick growth— teens make their own attempts to slow time, capture a moment. It is no longer necessarily the parents who want to slow time. Ask any parents if they are *savoring* their child's adolescence and they'll think you're crazy. Too often, parents are more than ready for their teen to become—or at least act like—an adult. Probably sensing this, or at least reacting against it, some teens attempt to capture, indelibly, their own moments, sometimes on or through their own body (i.e., with piercings, tattoos, etc.). Interestingly, this is sometimes referred to as teen rebellion, but against what or for whom? Can a teen be said to rebel against a parent who is rebelling against parent- hood? Teens with less of a need to stake such dramatic claims move away from the body as canvas, often expressing and defining themselves and their culture through artistic expression—prose, poetry, music, and the visual arts come quickly to mind. And of course, photography, the artistic expression par excellence of capturing a moment. More than just *capturing* something, photography as a process—and photographs as images—offer a reflective surface providing teens with the opportunity to create and navigate their entrance into the collective reality of their culture and our society.

Pre-1999

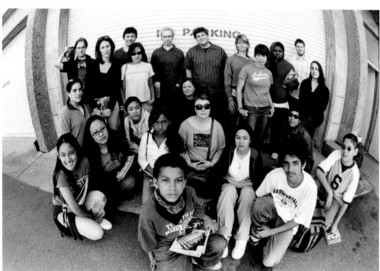

Joe Brook, 2004

However, in order to "shake" society through the use of photography, one needs a steady hand. This is what the mentors of San Francisco's First Exposures program provide. Mentoring in itself offers a form of artistic expression and a reflective experience upon which the teen can create an "adult" relationship. This book is devoted to the use of both photography and mentoring as reflective art.

Photography holds an obvious allure for teens. Unlike other forms of expression, it gives the impression of capturing not just time, but reality itself. This is of course illusory in that the photographer subjectively chooses and frames reality for the viewer. Fortunately for teens, it is not so easy to decipher the contextual realities of a photograph from their internal world (this makes the self-portraits here bold and unique in the teens' capacity to face the camera and present themselves both imaginatively and realistically). Teens are not necessarily hiding behind/within their images; however, they are able to play with creating and shaping reality by exercising their subjective control. In this way we can see the unique vision that teen artists reflect in their photographic work.

Mentoring is a reflective art in the best sense. And while the emphasis here is typically on the benefits of mentoring for teens, it should be noted, as developmentalist Erik Erikson does, that this emphasis may blind us to the "dependence of the older generation on the younger one."[2] Erikson uses the term *generativity* to define the mature adult's *need* to nurture and guide the younger generation. When stated as a need, as opposed to simply a desire, we can see mentoring as imperative not only to the teen's maturity, but also to that of the mentor.

It may be best to define the art of mentoring by what it is not: psychotherapy. These days everything from petting a dog to watching a movie to clothes shopping has its own "therapy." Even more conservative "talk" therapies have become overtaken by diagnostically based curriculums, workbooks, and "treatment planners." Mentoring, however, is free from the overt directivity (and sometimes invasiveness) of traditional therapy. In any relationship with adolescents, respect must be given to their sense of privacy and to their authentic voice, which must remain at least somewhat

unspoken/unknown. In mentoring, the relationship is always primary yet rarely defined/discussed when all is well. It may be therapeutic, but that's not for us to decide or expect.

Clearly mentoring is more than just teaching, more than just an apprenticeship. When a teacher is identified as a mentor, something more is being implied: the teacher has gone beyond his or her prescribed role in a significant, impactful way. As mentors, teachers provide something ineffable, something of themselves that feels more real, more personal, than the typical teacher–student interaction. Mentors offer a reflective, supportive relationship that adolescents can choose to make use of—or not. It is the unspoken quality—and teens' opportunity for personal choice—that is so attractive. The adolescent can take what is offered without concern or even acknowledgment. Gratitude is, of course, nice but not expected.

Mentoring is not parenting or an alternative to it. Teens, especially "at-risk" youth, are often said to *need* a mentor, as if a lack has been identified and, by his or her presence, an adult can simply fill it—"it" often being the function of a (missing) father/role model. Clearly, relationships are not so easy, and *filling* the lack of prominent relationships not so easily solvable. Fortunately for adolescents, mentoring is free from the entanglements of family dynamics, dramas, and inherited role prescriptions that teens must negotiate, integrate, and/or escape from as they enter their larger community. And while mentors surely respect the prohibitions our society places on adult–child relationships, within this frame mentors provide the opportunity for a positive adult relationship to the teen, possibly for the first time. Mentors invite teens to share in this larger world. Mentors represent and reflect cultural, societal, and artistic values, displaying them freely for teens to discover, process, or re-create seemingly on their own.

What the mentor offers to the artistic equation of photography is clarity of vision, organizing principles, techniques, and tricks that allow teens to better express their intentions. Again, this too is somewhat indescribable—or should be. Of course, one cannot—and should not—be able to look at the images in this book and make out exactly which was the mentor's contribution and which was the youth's. Mentors help facilitate

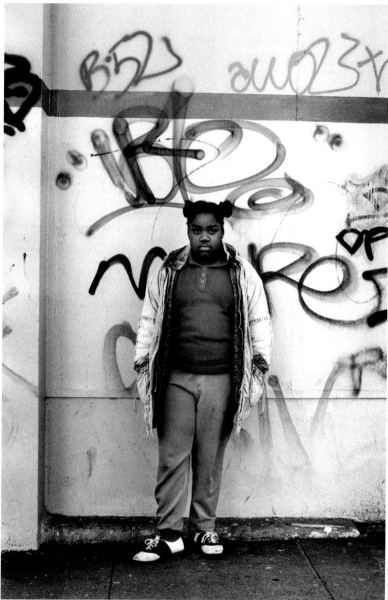

Edwina Smith, pre-1999

the "shaking" of society by taking on not the vision or voice of the adolescent, but, as suggested by Winnicott, the responsibility. The mentor can stand behind an image when perhaps the teen isn't quite convinced that the image—or even the teen—is worth it. It's easy to imagine these young artists' potentially paralyzing deliberations as they make choices about the display of their work. It is equally easy to imagine the mentor's words of encouragement and enthusiasm. It is the steady hand of the mentor that allows for better shaking.

Let's be clear. With all this talk of reflective surfaces, this is no mere point-and-click snapshot book of amateur adolescent photography—no simple capturing of a moment in time, no plaster handprints. We're not just looking back knowingly and admiringly at the adolescents' creations: as if we've seen before what they're now seeing, that we already know what they're just now learning. There is real play and artistry at work here that is both creative and informative in ways that are unique, enlivening. Here, we are privileged to experience each teen's unique vantage point. For instance, a few of the photographers here offer a unique view of childhood that is insightful and poignant. These images are never merely a sentimental looking back. Childhood here viewed through the adolescent lens is anything but idealized. Some of these images portray children in a very real, photo-

journalistic way. Others distort and deconstruct the images of childhood, sometimes humorously, sometimes hauntingly. In many such pictures, that which typically signifies adulthood and that which signifies childhood get mixed up, reversed, and confused.

The images in this book inform us about both the artistic and mentoring processes. But again, it would be silly to try teasing out which represents the young artist's vision and which the mentor's steady hand. While we can clearly see the images, the imperceptible quality of the mentor's guidance and support must be inferred. Perhaps we could say that mentoring itself is an artistic statement of love and generativity offered to the next generation's artists.

Matt Carges is a licensed marriage and family therapist currently practicing as a supervising therapist for children and adolescents in psychiatric inpatient care. He lives in Portland, Oregon, with his wife and two children, one of whom is presently…an adolescent.

NOTES
1. D. W. Winnicott, *Playing and Reality* (London: Tavistock, 1971), 146.
2. E. Erikson, *Childhood and Society* (New York: Norton, 1950), 266.

STUDENT WORK 2006

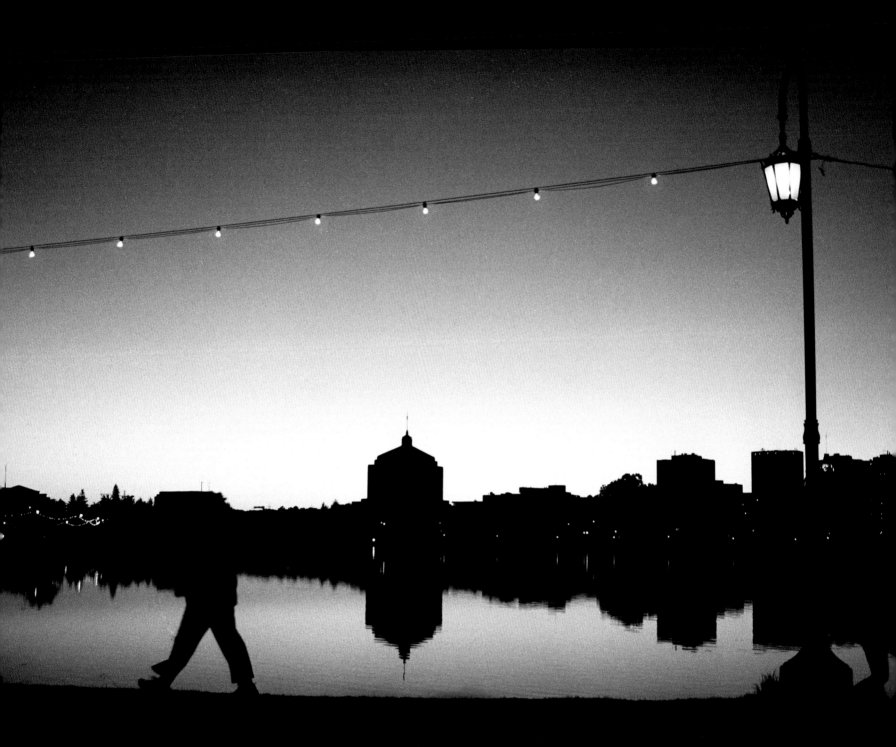

The relationship that people share with the night is that they rely on the night. They change at night; they will do things and go places that they would not do in the day. The night brings people together!!

My relationship with the night is that I feel like a different person. At night a new me comes out: a livelier, wilder personality. A lot of events happen at night, and I want to be a part of them.

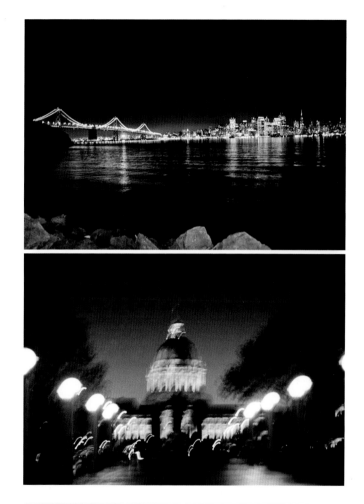

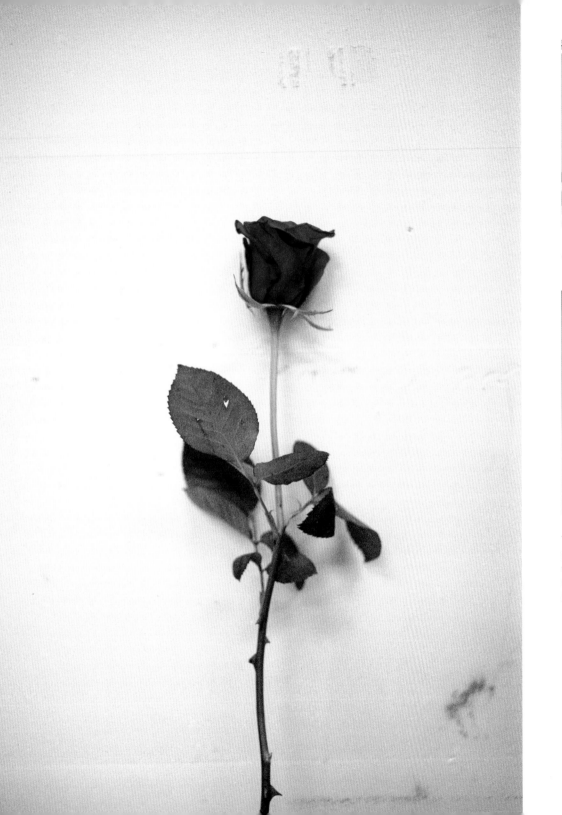

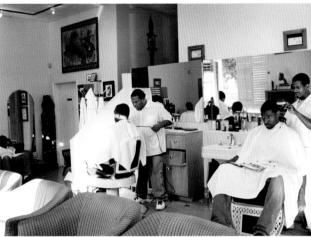

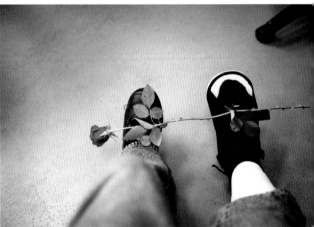

The barbershop shows great unity in urban neighborhoods. Bonding between old and young—great conversations and words of wisdom that just fill the whole place, like all life's lessons in one place.

I use the rose to expose the truth behind every photo. Just like these have common ground, everyone has common ground too.

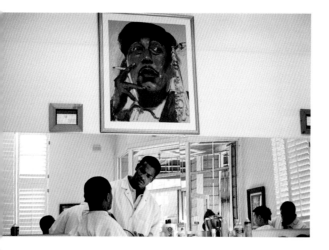

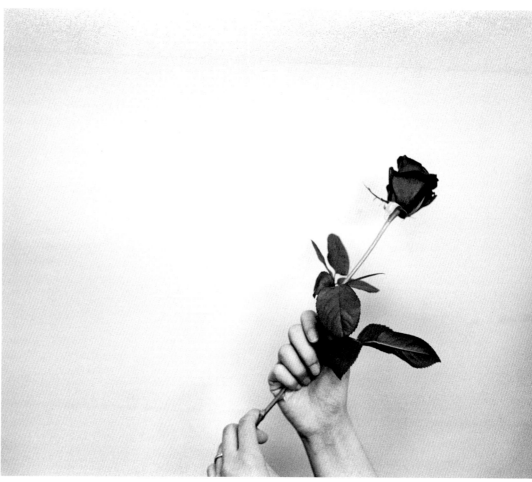

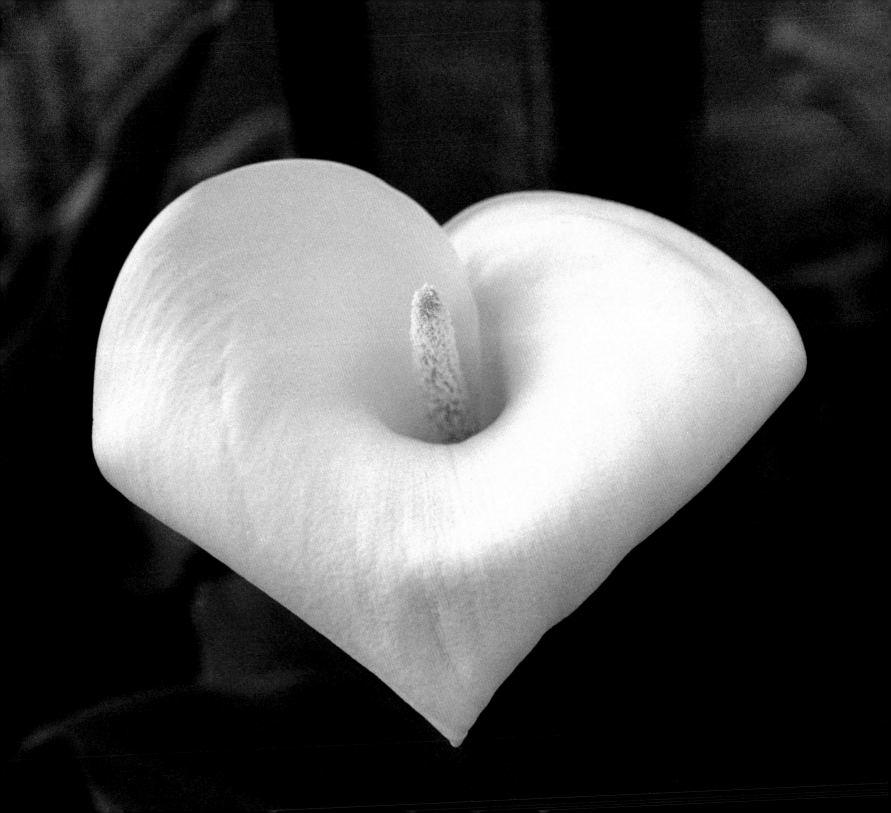

A Flower's Heart.

This picture on the left is an accident of nature. It was a moment of the calla lily's life when it had this heart shape.

Nature is so amazing and beautiful - we get non-stop surprises. Never stop thinking about your place in nature and your relationship with it.

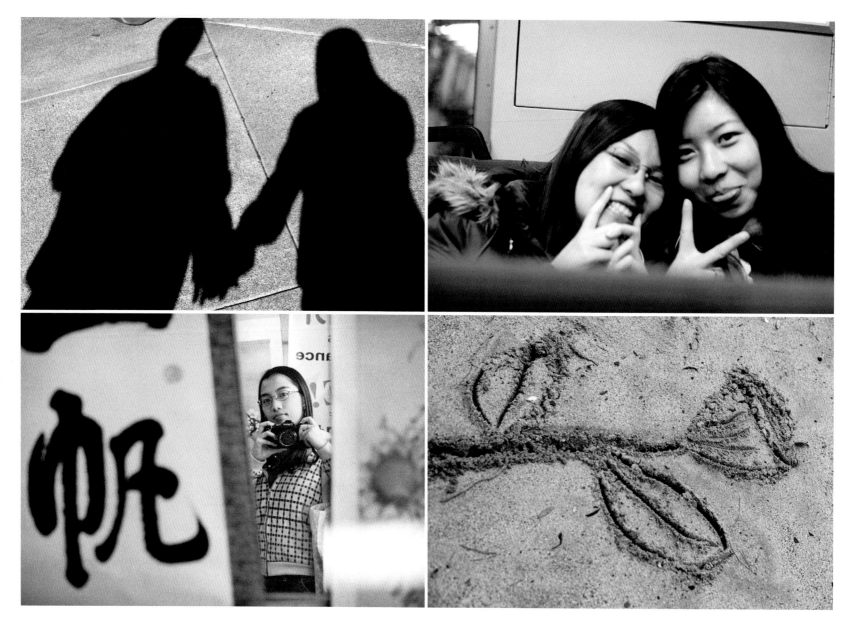

top: Date
bottom: untitled

top: Cheerful friends
bottom: Meaning of a rose

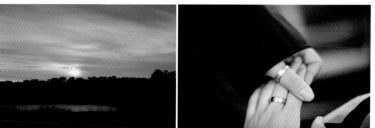

top: Night-time moon
left: Daytime sun
right: Warmth

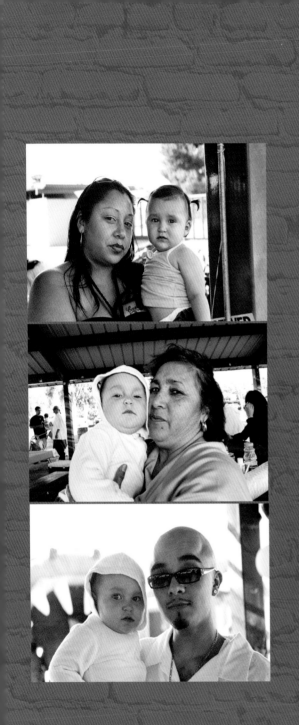

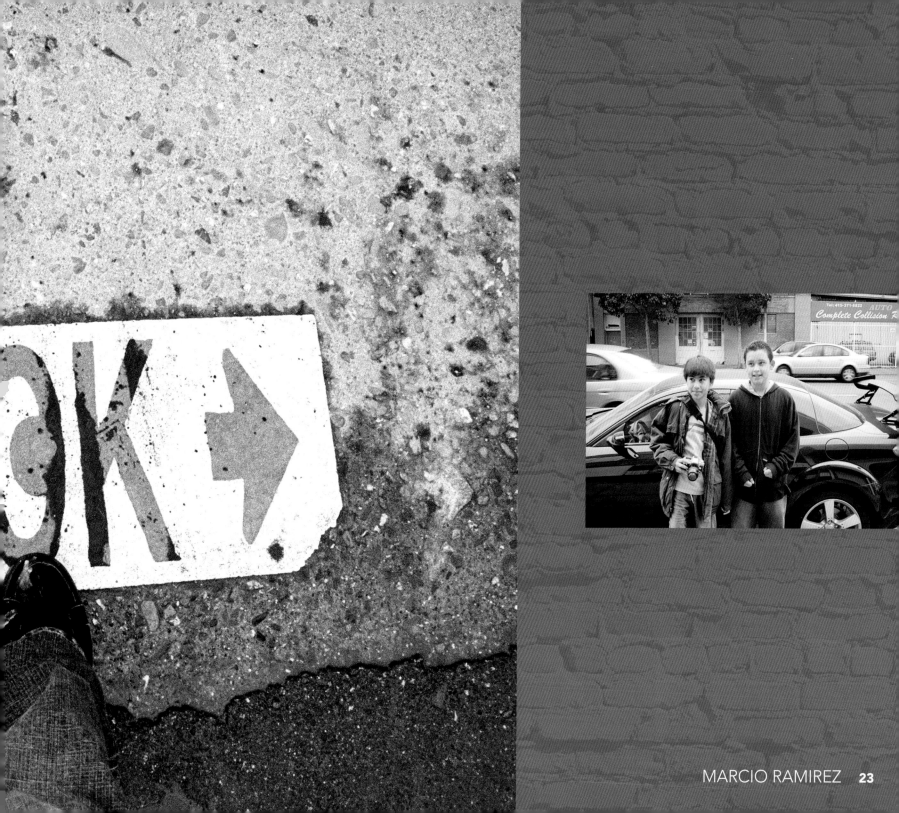

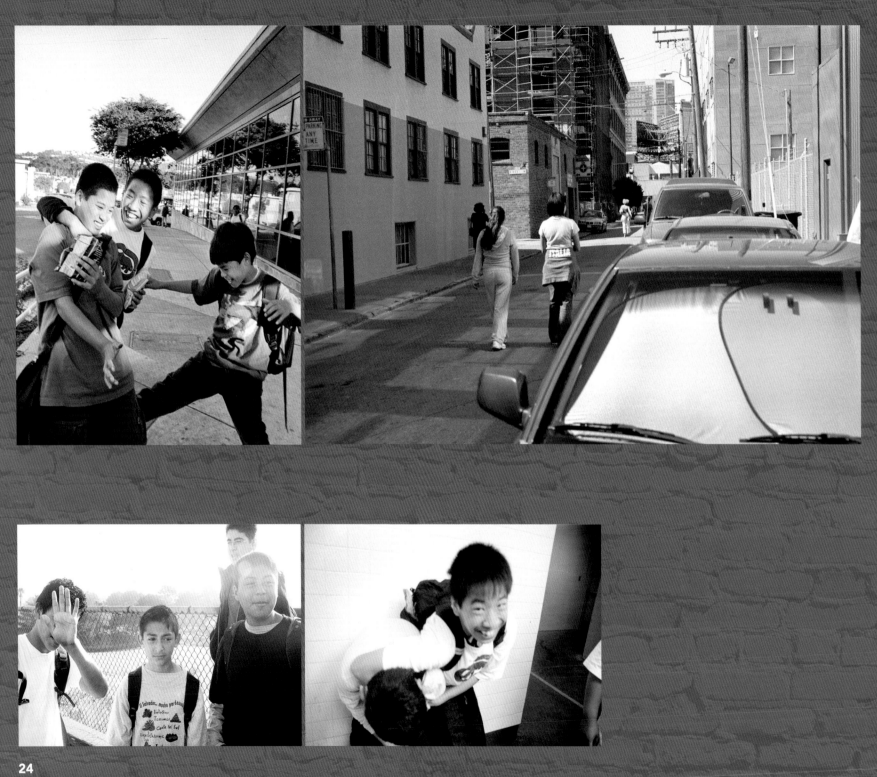

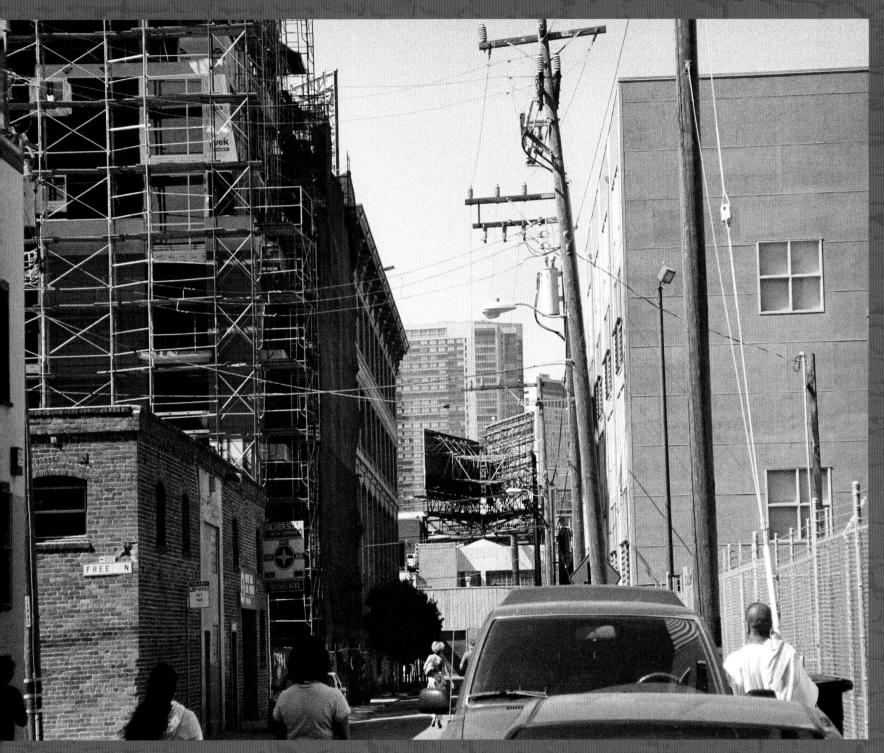

Mom's feet...

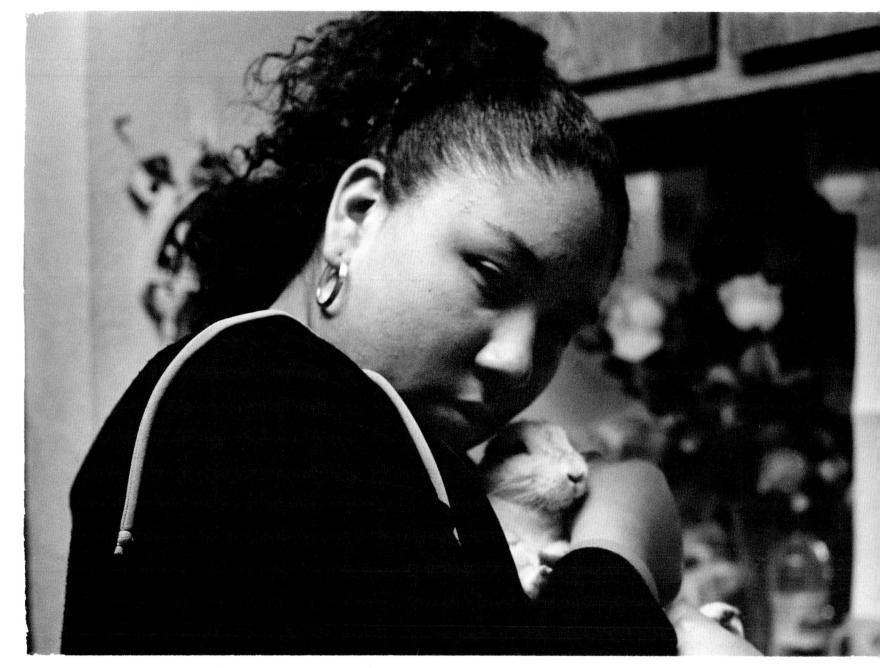

Diana and Junior

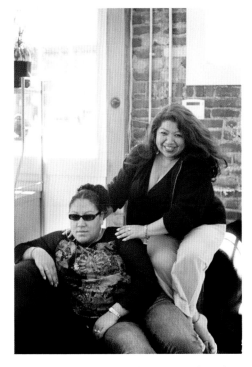

Mom and Diana's relationship—bonding

Dad's house in Sunset district

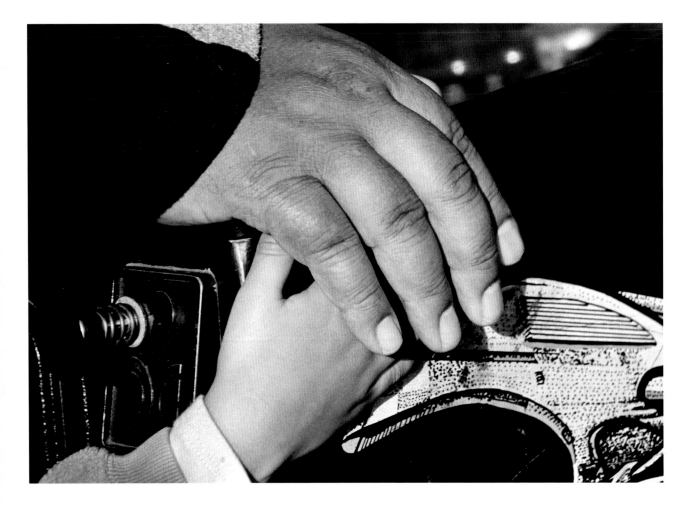

"Those who live in the Lord never see each other for the last time." —anonymous

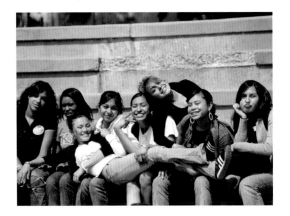

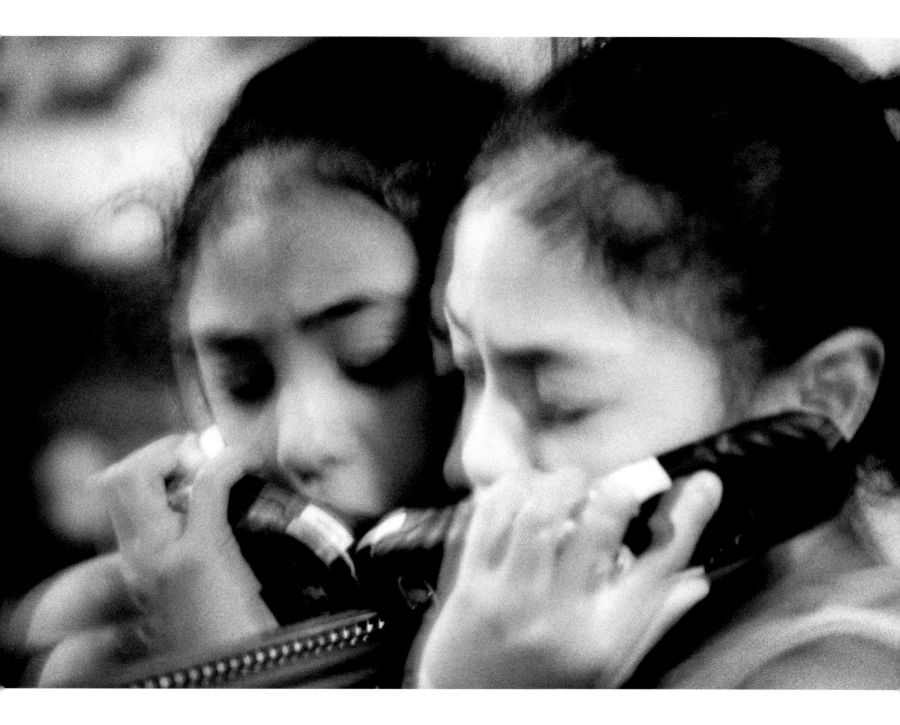

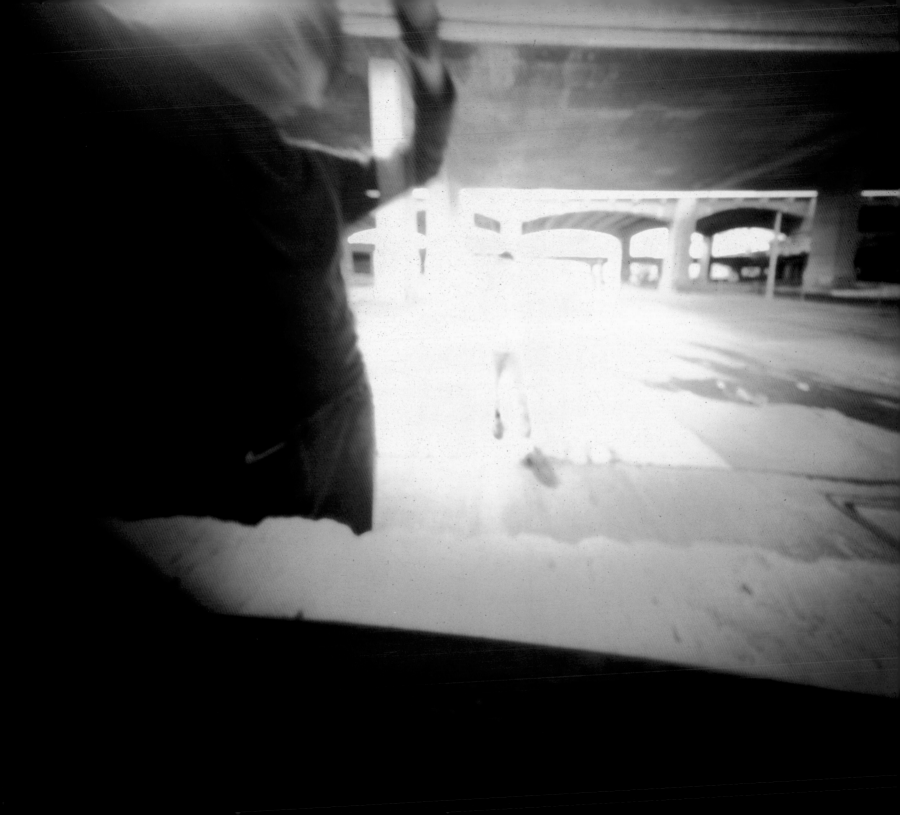

pinhole

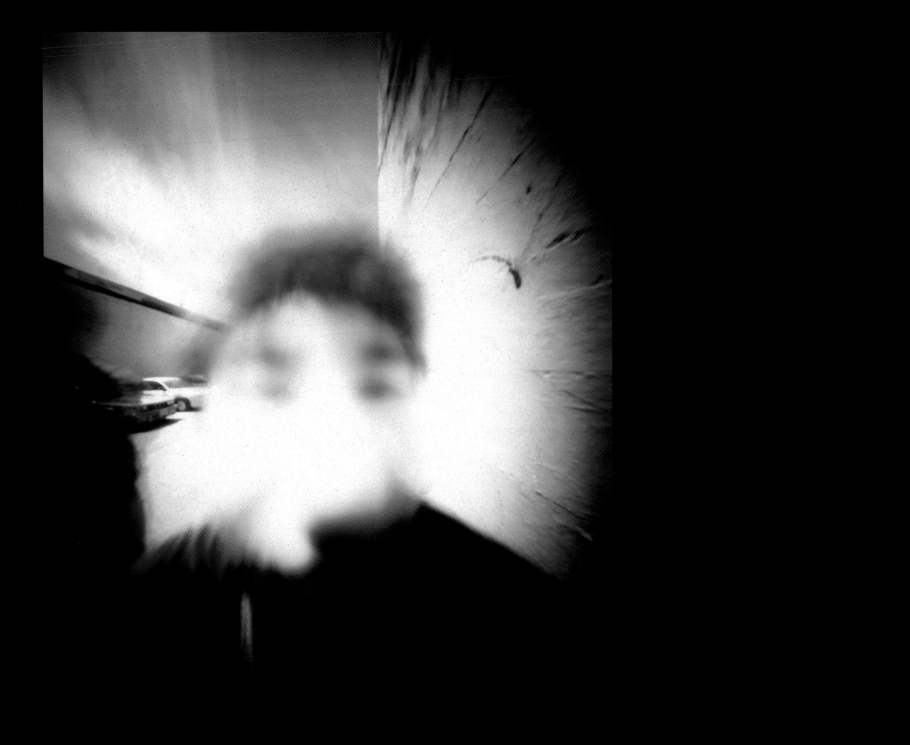

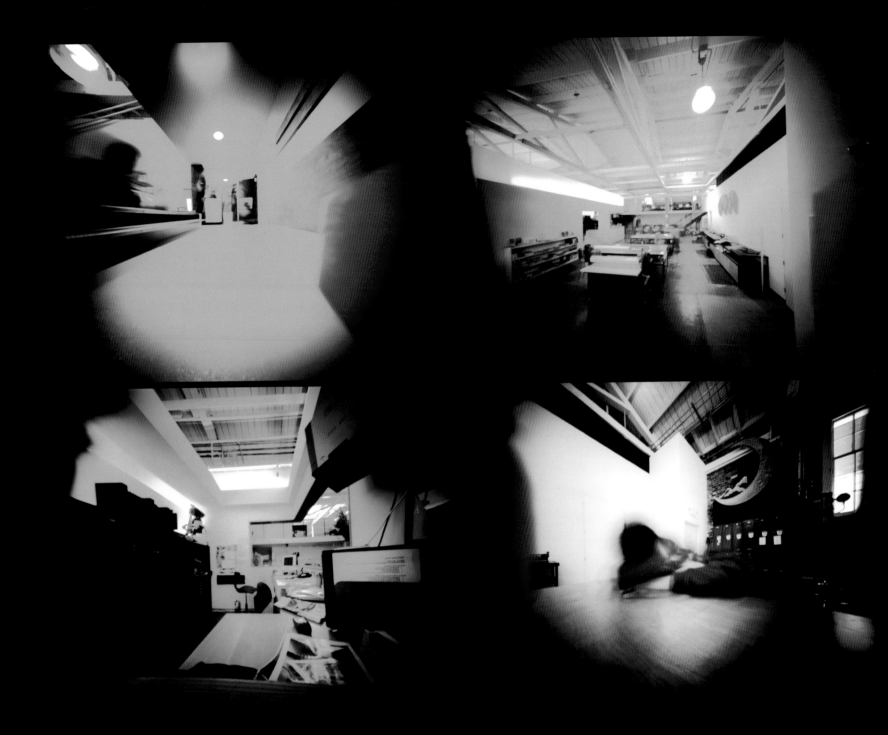

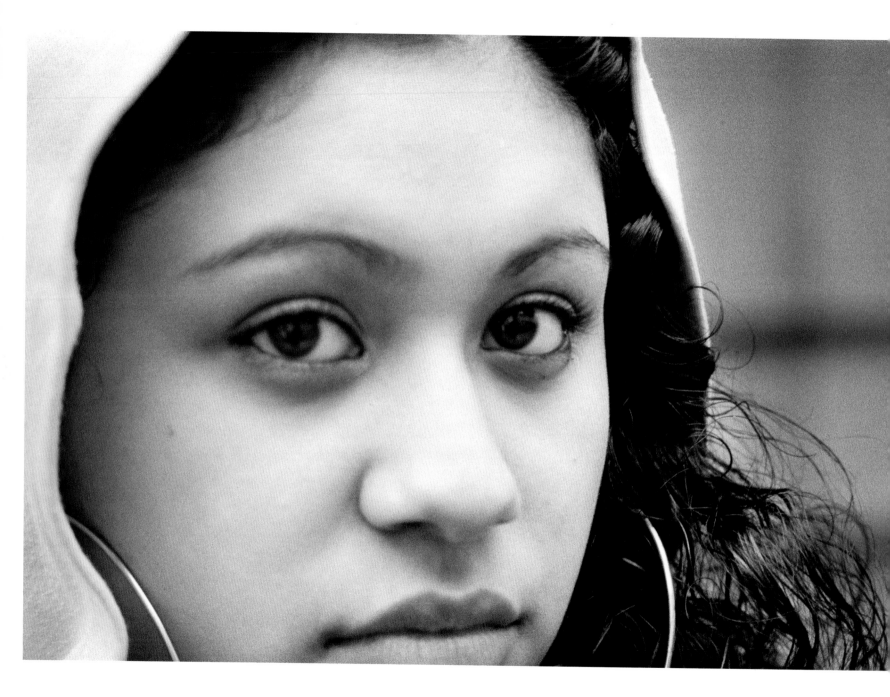

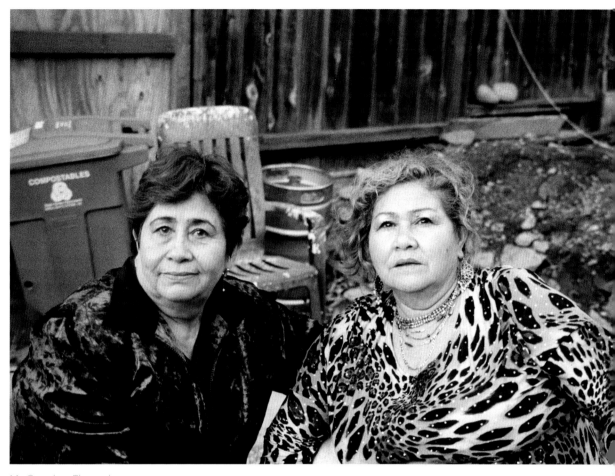

My name is Daniella Espinoza and I am 15 years old. I am Hispanic and I live in San Francisco's Bayview district. My images represent the close relationships I have with my family, friends and my religion. I am giving people an exclusive look into my everyday life that is "my real world." I am very happy with the pictures I have taken. I have learned about myself while developing my talent. I have never done this before. Now I know I love taking pictures and just expressing how I see my life and how I deal with it. I feel excited and proud about my accomplishments over the year. By getting help with my mentor, that gave me a little push and now I know what my style is. I want to be able to show people that in different communities we all do not have the same experiences and in "my world" the youth have to deal with hard decisions, knowing right from wrong and getting their voices heard.

My Grandma Elsa and
my Aunt Reina—Latina sisters

Carlos, Karla, and Jaime—three great friends

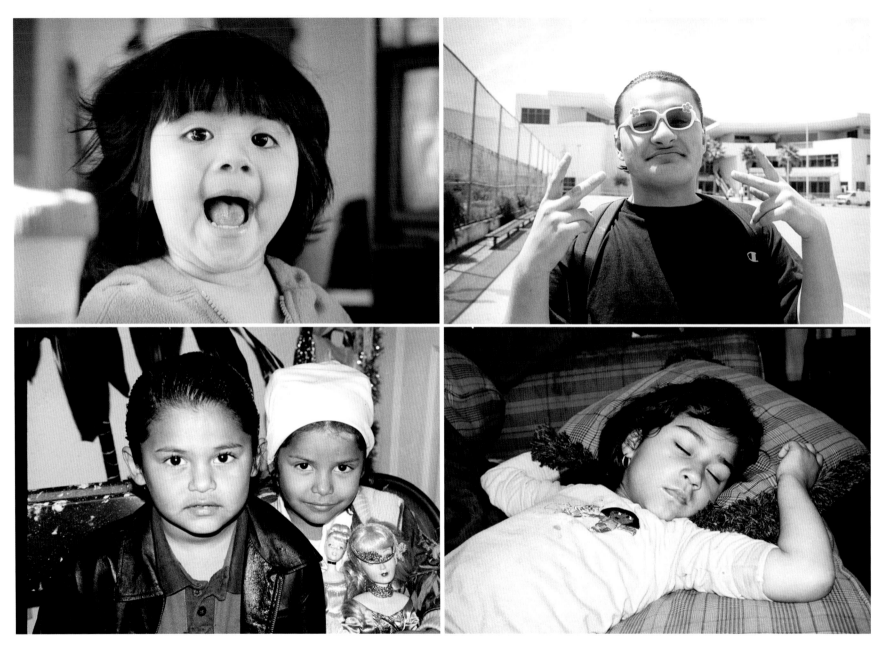

top: Eileen, my baby cousin

bottom: Jasmine and Andy are twins

top: My buddy Carlos. "Put your stunna shades on!"

bottom: Jocelyn sleeping

El Dia de San Lazaro

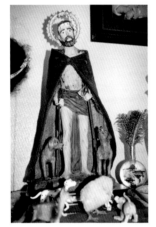

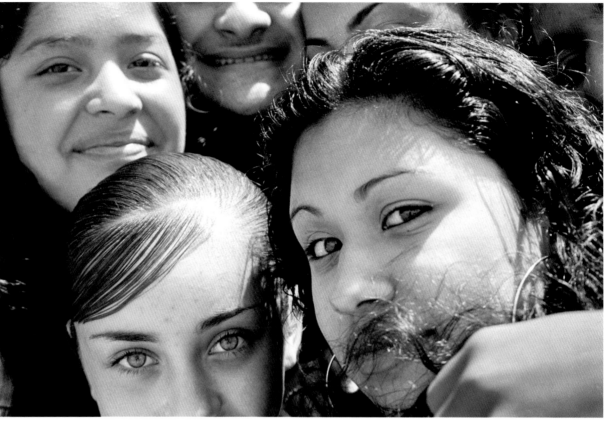

Yesenia, Belinda, Rebecca, Carlos, and me. Class of '09.

Here is my baby sister Jocelyn representing
our cultural flag—having pride for where she's from.

My Grandfather Dionicio, R.I.P.

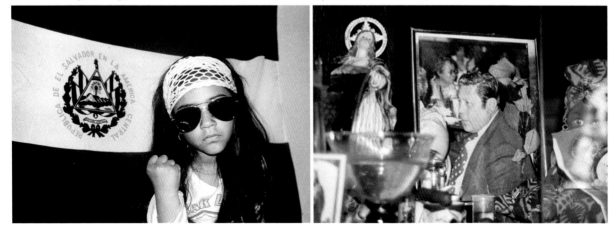

THE THINGS WE USED TO DO

My relationship with my Grandma has always
brought wonderful memories,
but every day without her is difficult.

We went to Starbucks, ordered coffee,
and I smelled the sweet aroma
of your coffee as I sat there.
Now all I do is sit there and reminisce on the fun we had.

You always gave me confidence and
wisdom to be a respectful little girl.

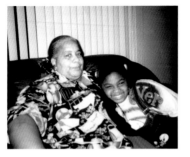

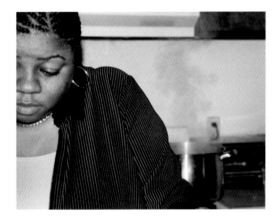

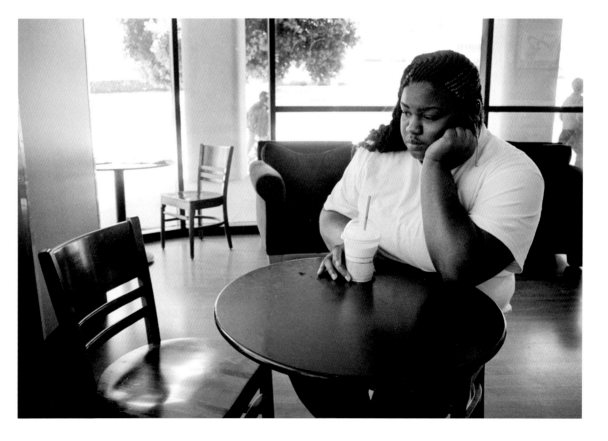

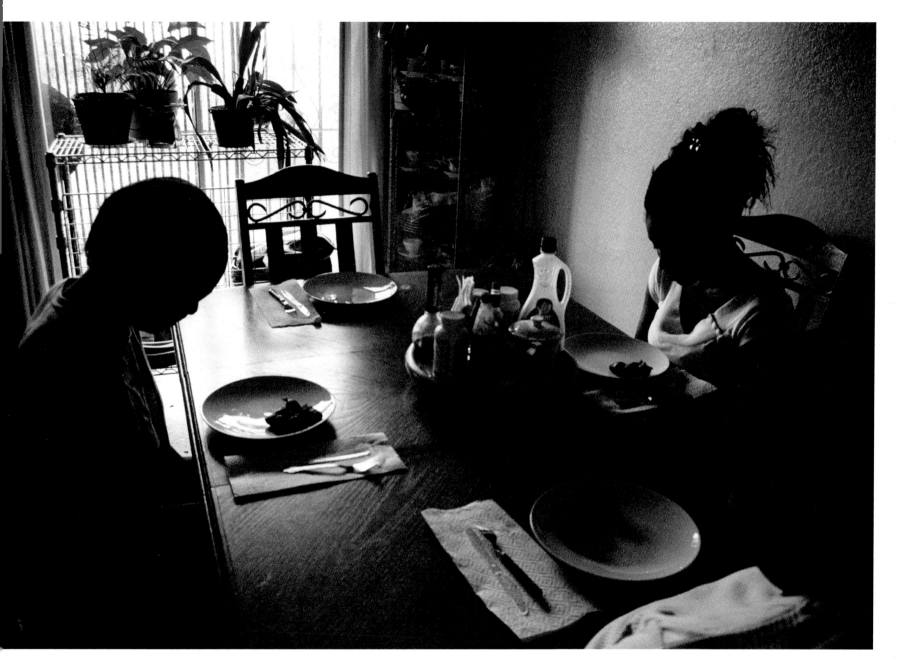

Sitting at the dinner table has always been one of the toughest things I have to face every day.

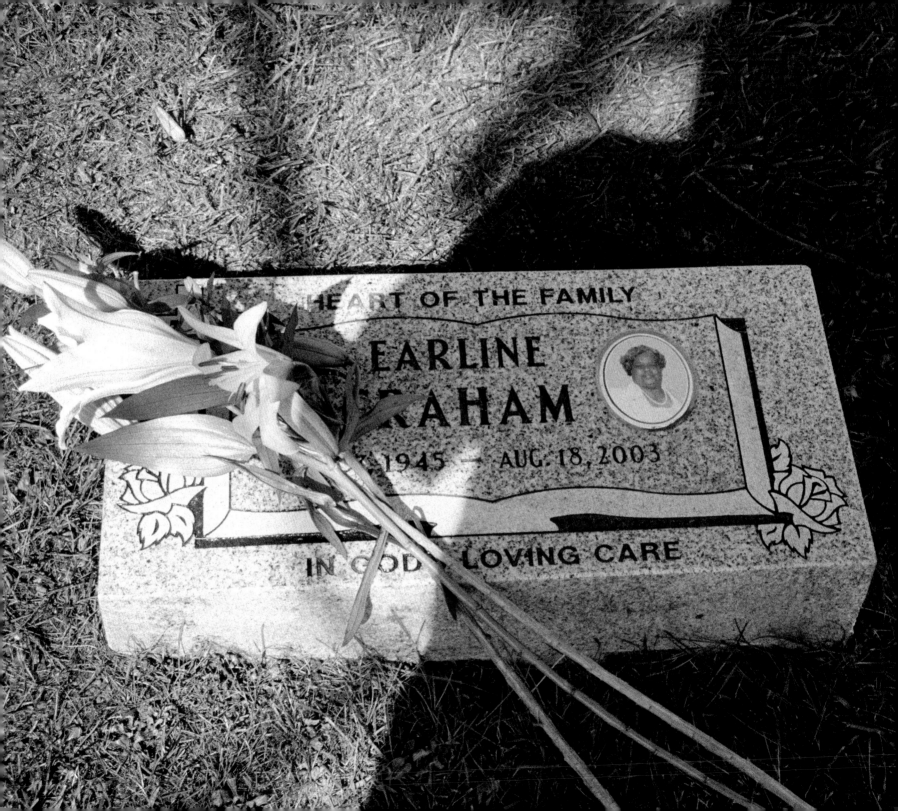

Now that you are not here,
 I feel like my life isn't complete.
Every day without you,
I can't live life to the fullest.

Italy = dream

as I look at the clock, I close my eyes, I wish I could sleep, but those people next has me in some despair I get home, only to sit in front of the TV and let time here in San Francisco, my mind filled with nothing more than with pure distress through Rome, Florence, and Venice; it's just too bad we didn't go to Sicily. if it was time through which I had kept. For once in my life I was only to hear my sister wake me up, and find that I had only dreamed.

to me won't stop their fuss. I open my eyes to find myself in Flow: what I am going to do about tomorrow I don't know. went to sleep in the melancholy city of San Francisco So many fond memories in my heart I kept. With free of duty. Then it was all starting to fade, as I -Jennifer Murcia

got onto the airplane last I remember I was flying over Munich I woke up the next day in the country of Italy I walked through camera I captured only a bit of Italy's beauty. As I night falls, I stare out at the stars, yet my heart is filled with unrest. It's Italy, just another city block. I look out the window, in despair, wishing I was truly

It's cold and rainy outside, as I sit on the 14 Bus. It's 3:30pm here. My school work is much more than I can bear, It truly another rainy day as I make my way back home. I'm place. I didn't know. Before I knew, it was cruising the Italian streets surrounded by monuments, it's as and the sea, or at least that's what it seemed.

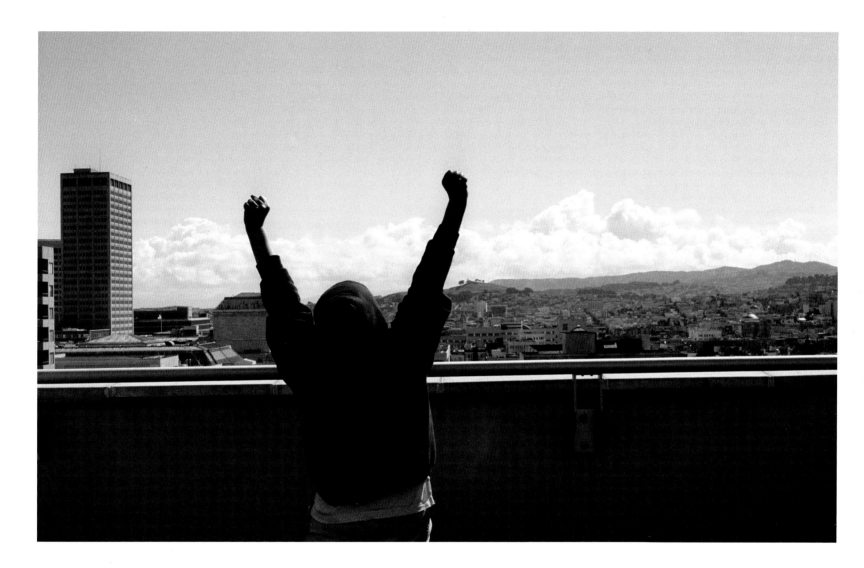

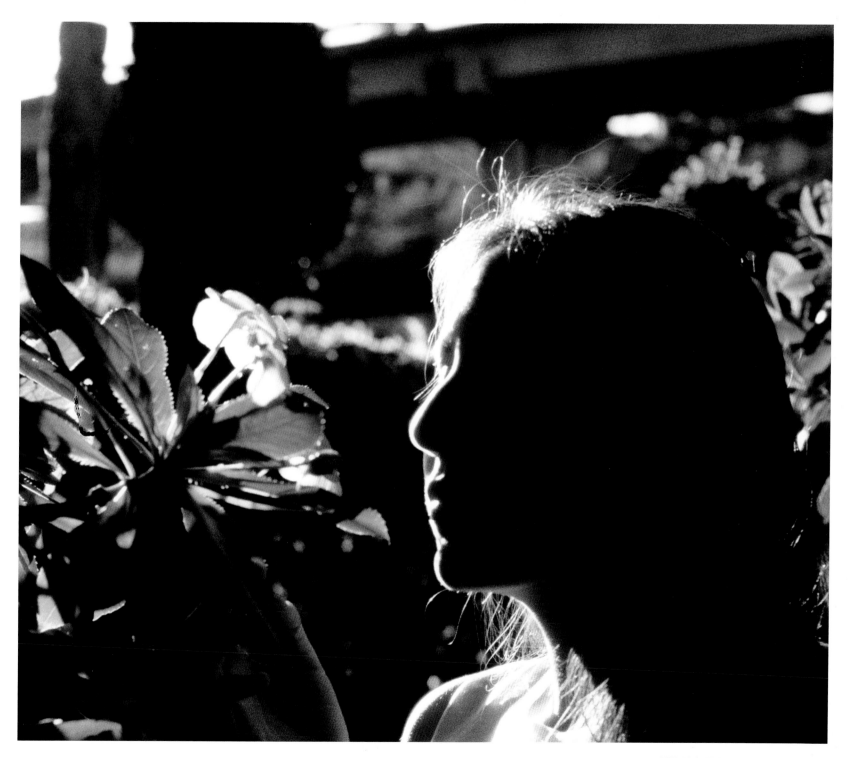

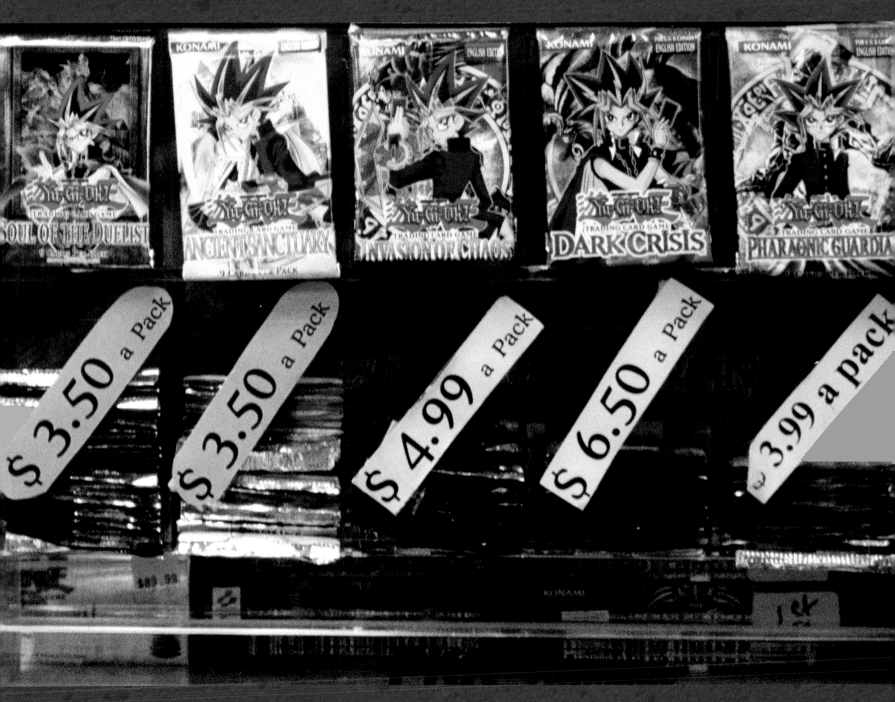

These photos show the different relationships that people have with their Yu-Gi-Oh cards and the people that they play the game with. I first started playing the game around spring of 2001. My cousin Curt and Uncle Mike got me started because I would always see them fiddling with their deck of cards and hear them talking about the TV show. For a while I wasn't interested and thought what they were doing was for geeks only and thought it was a waste of time.

After being bugged by my cousin and uncle to play with them, I picked up some cards, played, and lost a game. I asked for a rematch and lost. This continued on for a while until my cousin decided I was no longer a challenge. By this time I vowed that I would never lose to my cousin again and when I won I would completely crush him!!! So I committed myself day and night to master this game and its rules, every nook and cranny 'til there was nothing left to learn and dethrone anyone who stood in my way, on my road to victory!!!

When I started taking this game more seriously I realized that it took more time and strategy than what was shown on the Yu-Gi-Oh TV show—where the duellists just threw down a bunch of random cards and talked trash to each other. We still talk lots of trash but, mastering the game takes long hours of research, planning what you want your deck to do, play testing (trying out a new strategy with my sister), and most importantly money to buy cards!!!

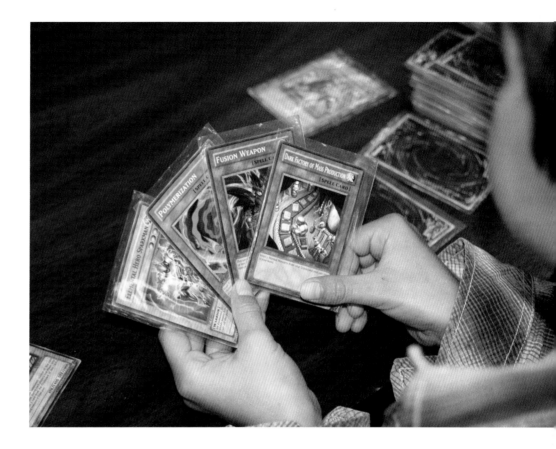

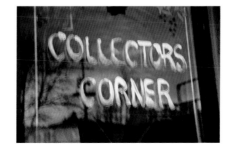

We card geeks exchange knowledge, new card strategies, compete in tournaments, trade/buy cards, eat pizza and soda and chips, and more at Collector's Corner. I started going to Collector's Corner a little after I got a hang of the game and figured out what type of deck I like playing with. The owner, Jason, is very friendly to all his customers and gives us good deals on the cards that he's selling—especially if you're able to wheel and deal. While I like him as my friend, I respect him a lot because he handles business and is successful at what he does. Collector's Corner isn't just a place to buy and trade cards; it is also where duellists come for serious tournament competition.

Yu-Gi-Oh isn't what I thought at first. It's not just for geeks—it's really for everyone. And what happened to my cousin? I've already whooped him a couple of times!

HEY! Do you remember
the first time you learned
something new and excit-
ing that you are still in-
volved with and every time
you see it or something
similar you start thinking
about how it changes your
perspective on how you
see things?

This is what happened to
me when I started skate-
boarding as well as with
photography—things just
seemed more interesting
to me.

For instance, where
people saw a whole bunch
of benches, ledges, and
stairs, I saw something to
skate or photograph.

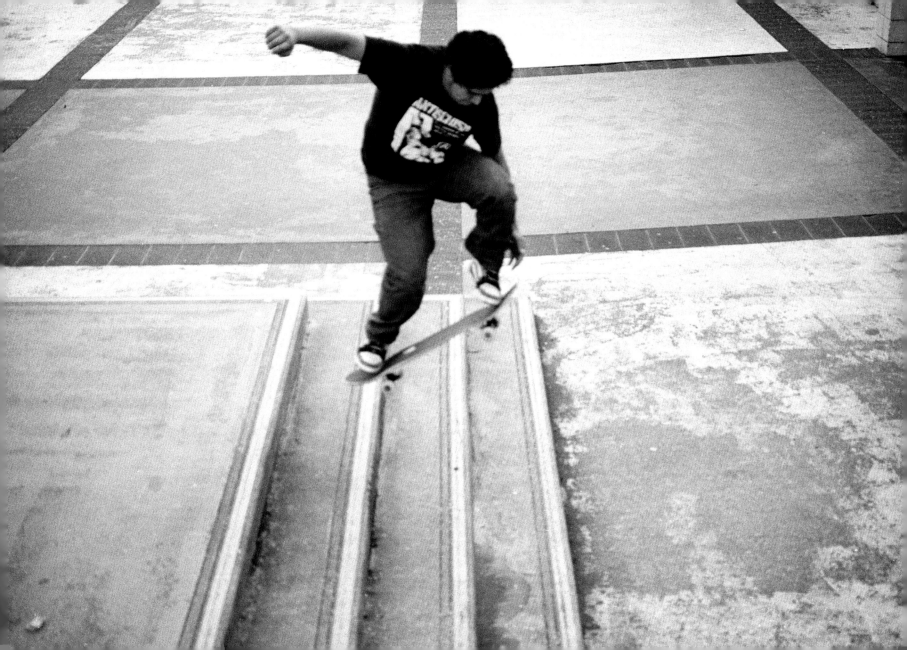

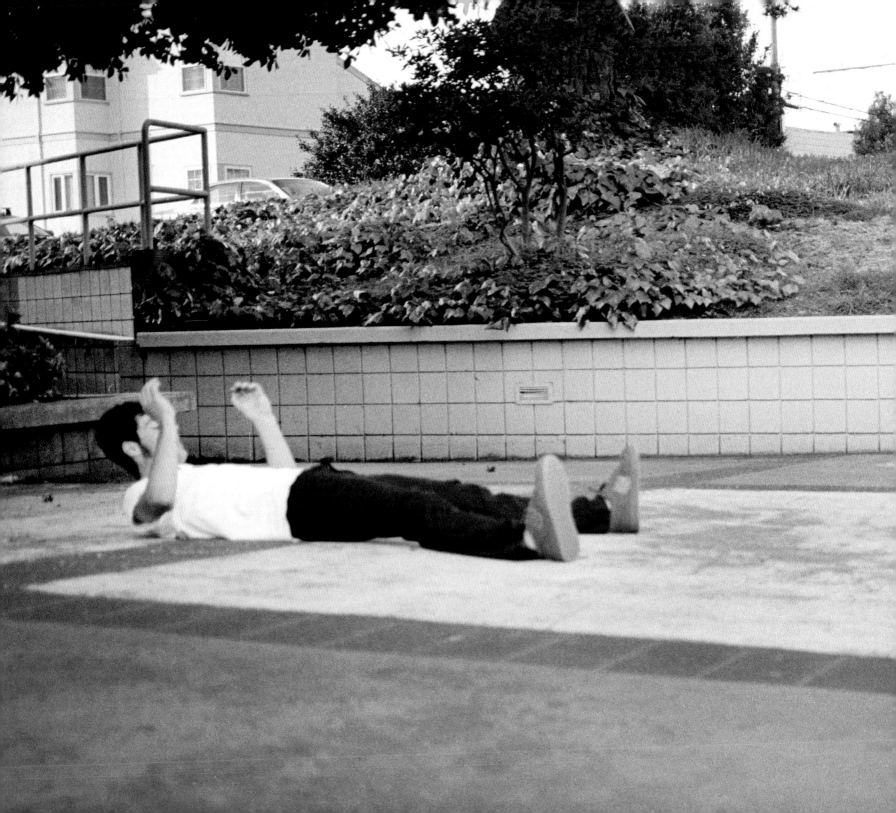

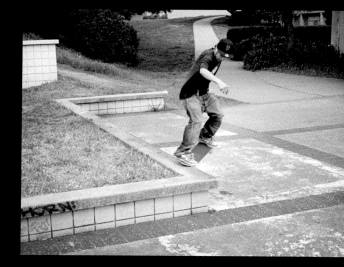

My friends know exactly what I'm about when I pull out my camera while everybody is skating. My friends even tell me, "Hey I got a trick for you" or they call me in the morning and ask me, "You skating today? Bring your camera."

Skateboarding has changed what I see wherever I go.

IVAN FERNANDEZ **57**

Erika, Garvin, Central Richmond

Precious, Central Richmond

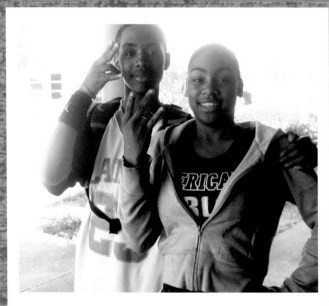

Alex and Akilah, Narf/Noila
North Richmond

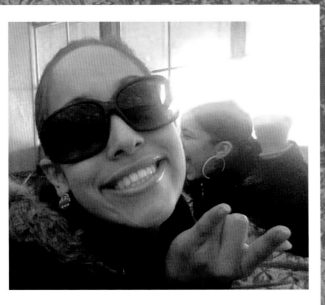

Natasha, 25th, Richmond

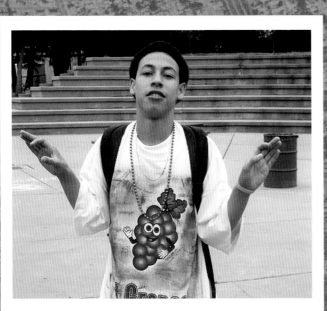

Wally, Deep C, Central Richmond

1800s, Narf, Central: these are all neighborhoods in the East Bay. These kids represent their neighborhoods by throwin' up hand signs symbolizing where they're from. Richmond and Oakland are the two most "popular" places to come from, and if you were from anywhere else, you just didn't talk about it. This ranged from youth even up to adults. What interested me in all this was that it was a form of relationships.

When you think of relationships, what do you think about? Best friends, sister-brother, boyfriend-girlfriend, the obvious stuff. But what about the deeper kinds, what's under the surface? I always noticed how a lot of the people, most being youth, kept making all these hand signs. At one point I'd be shooting three people and suddenly there'd be eight! They saw people throwin' up their neighborhoods so they'd want to throw up theirs too, or sometimes they'd just want to be in the photo. Then they'd begin asking where each other was from. Depending on the answer, you'd get a "good job!" or end up debating on which neighborhood was better.

The funny thing was when I asked them why their neighborhood was better, they couldn't tell me! They all said the same thing. "Cuz it go," "Is cool," or just plain "I don't know" were the most common. They have so much pride and this seems so important to them, but they couldn't say why. When something goes down, these kids got each other's back and will always come through. The fact that they're from the same place forms the relationship. They've got that "Ride 'n' die for ya" mentality and it shows through.

No matter the memories, good or bad, they'll always remember where they come from. Even when they've moved to a better place, that neighborhood will always be their home. 4500, 9800, Costa, where you from?

All map images courtesy of Google Maps, 2006

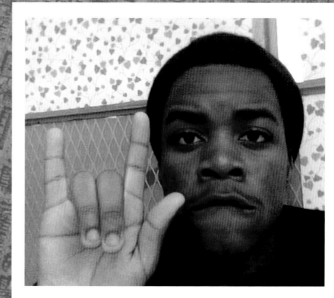

Lamar, 4500 block High St.,
Middle East Oakland

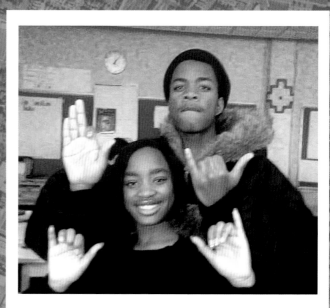

Lamar and Janisha, 4500 block
High Street/E.S.O, Mid East Oakland

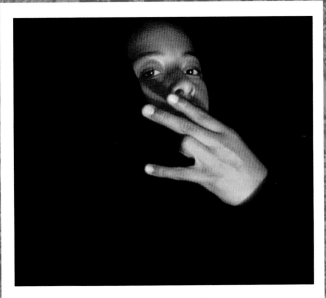

Reggie, 9800-10000 Walnut,
East Oakland

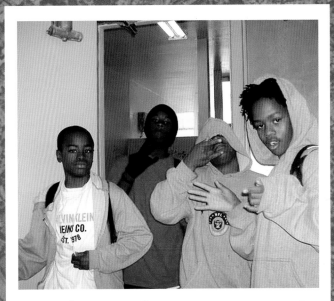

J, Eric, Devonte, Damarie, 3500 block East
Oakland, West Oakland

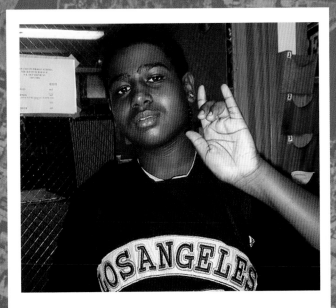

Pervonte, West Oakland

Throughout yours and everyone else's life, you will reach hardships, inequality and discrimination. However, don't let it get you down because there is always someone there who will care; you can always do something about it. Enjoy life - it's too short to be arguing and fighting 'til you die.

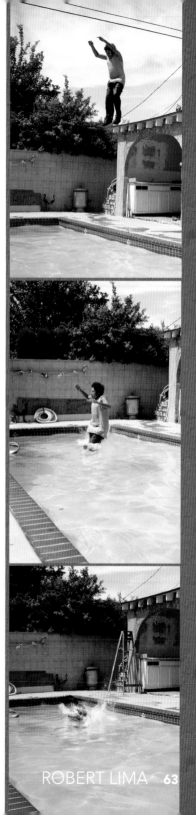

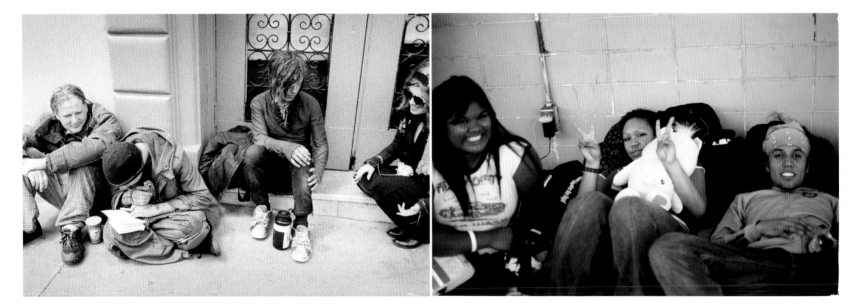

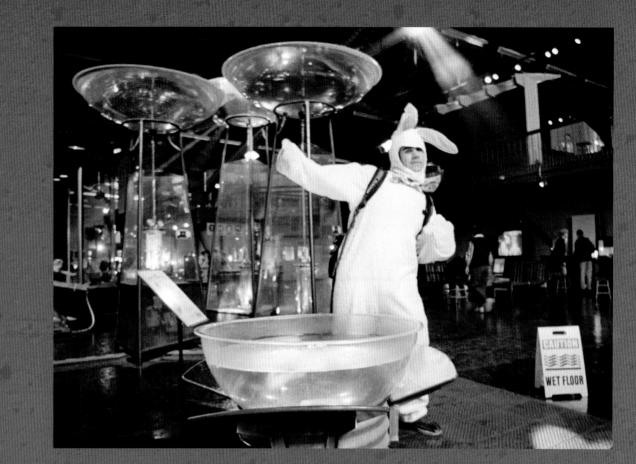

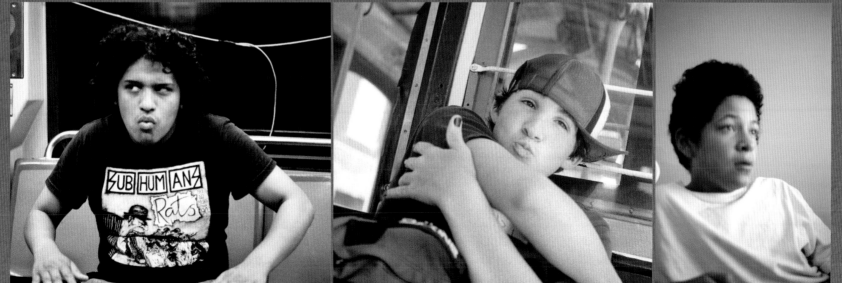

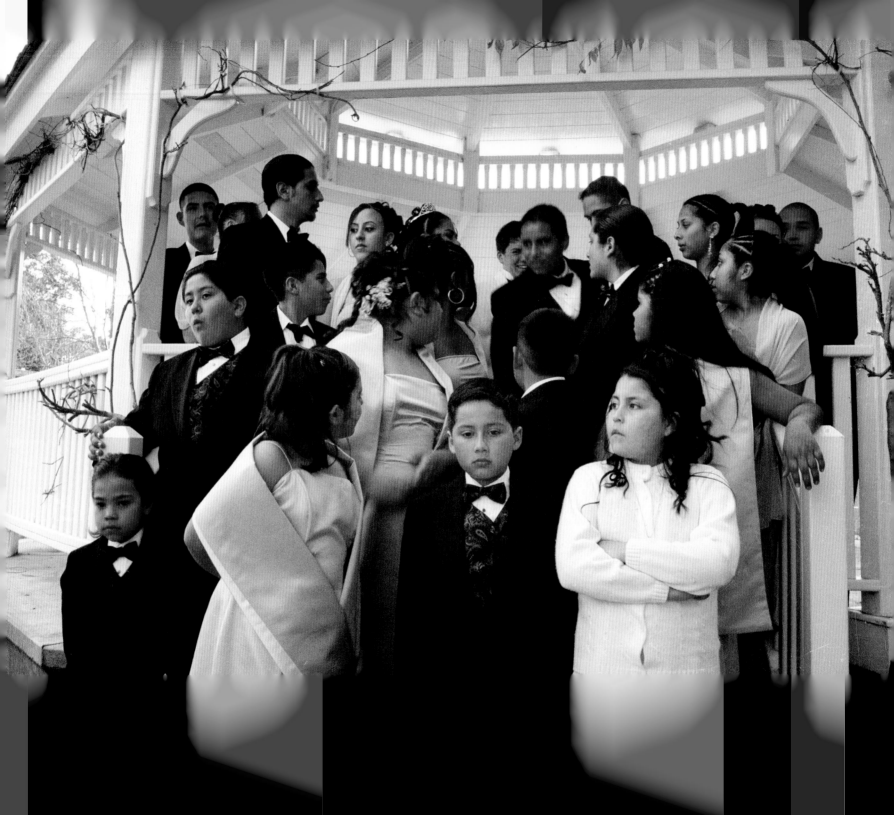

Sibling relationships are different than other relationships because siblings are always there for you, will risk their life for you, means you have someone to talk to besides parents when you're in trouble, are your blood so it's the closest you'll get no matter how mad you get; you'll still love 'em.

"The 5 you's":
you.... can embarrass siblings
you.... don't need a search warrant
you.... fight for attention from your parents
you.... have common genes you don't know about until you tell them
you.... look like each other more than anyone else

Sisters are the clean ones
In motion with each other
Brothers are the messy ones
Love is clean and messy together
Intuition for one another
Never-ending fights
Great connections
Strong feelings

Sisters are sassy and
Independent
Strict
Trustworthy
Emotional
o**R**ganized
Stylish

Brothers are bossy
Rowdy
Over-protective
Tough
Honest (most of the time)
Egotistical
Risky
Smelly

Brother / Sister Love is
Lucky
Optimistic
Very in tuned with each other
n**E**rve racking

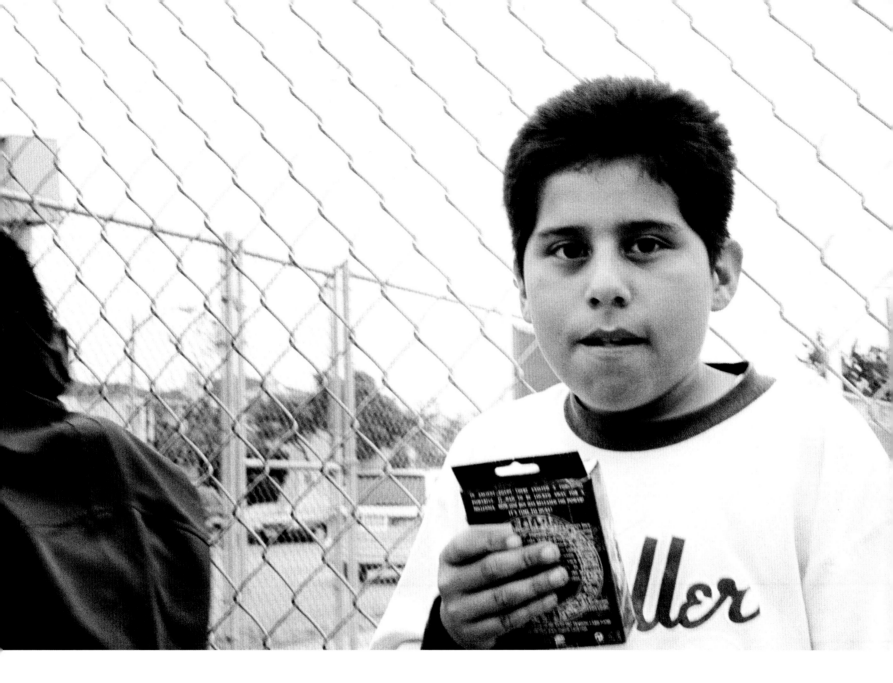

With boy friends, if they leave it's like one bus goes but another one is always coming, but with siblings your bus is always there. Never-ending sleep-overs. If you are an only child, no one has your back if you are in trouble. Siblings are helpful when you're sad. When you go with your siblings anywhere, no questions asked besides where you're going, and when you're coming back (not with friends). You can tell siblings deep secrets.

FRANCHESCA HERNANDEZ **69**

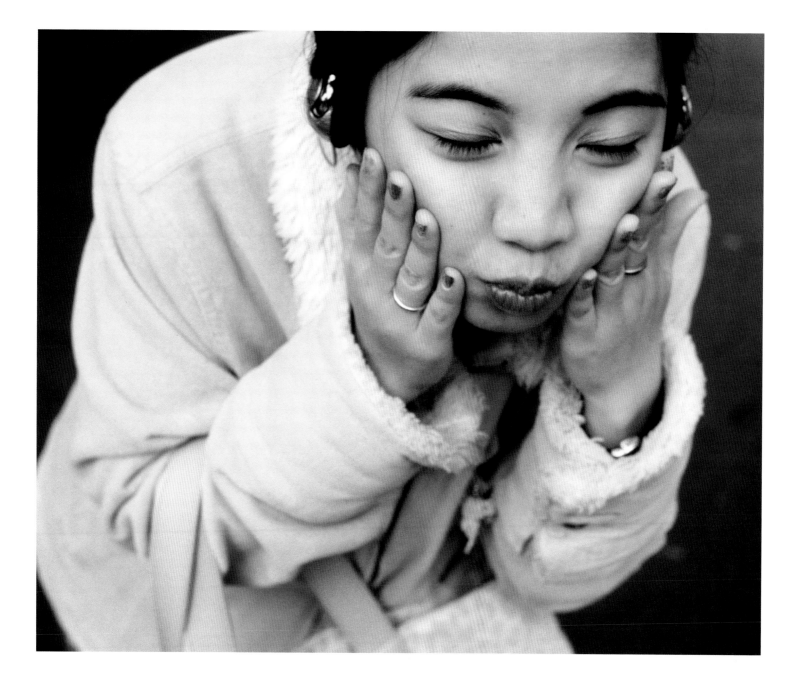

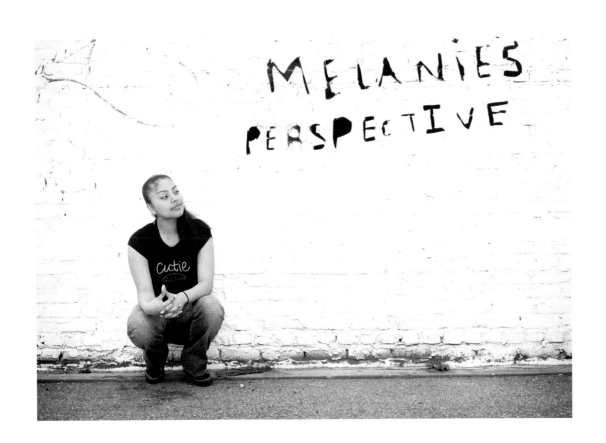

MELANIES
PERSPECTIVE

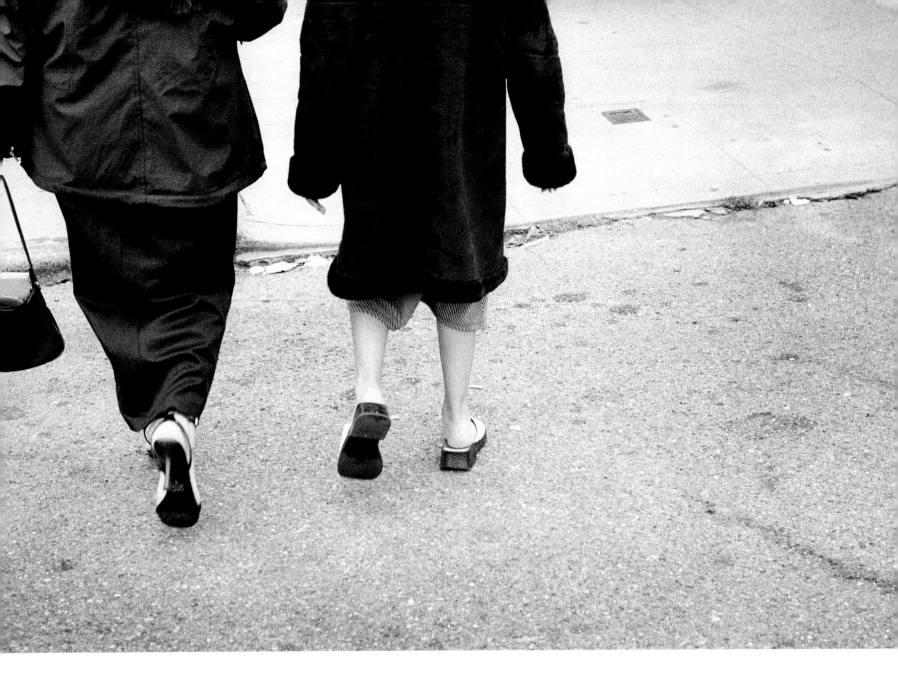

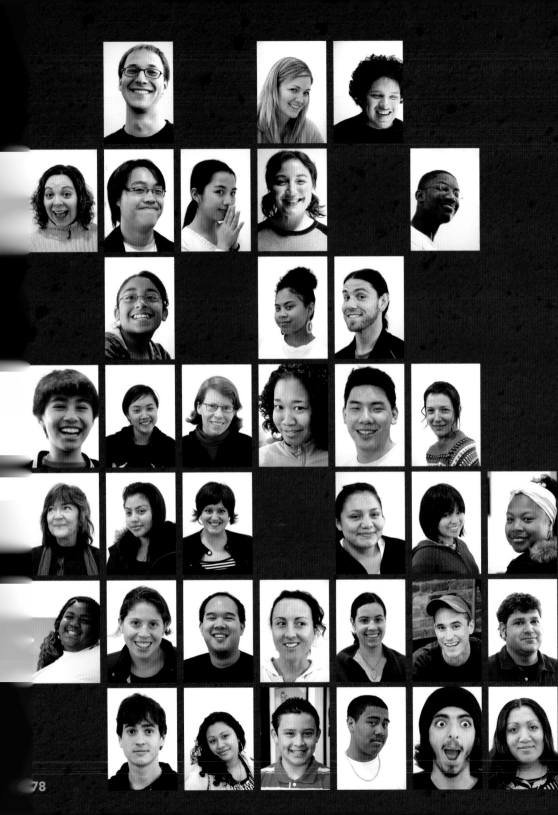

THE FACES OF FIRST EXPOSURES 2006

STUDENTS
Bethany Castro, age 16
Jeremy Castro, age 18
Naomi Castro, age 15
Jontonnette Clark, age 16
Dijorn Cole, age 16
Daniella Espinoza, age 15
Ivan Fernandez, age 18
Jason Gershow, age 12
Karen Gochez, age 16
Franchesca Hernandez, age 12
Robert Lima, age 18
Ai Mei (aka Jada) Ma, age 18
Jennifer Murcia, age 17
Marcio Ramirez, age 13
Melanie Solis, age 15
Stanley Wong, age 18

MENTORS
Madika Bryant
Zoe Christopher
Lindsay Coleman
Lori Eanes
Tara Ford
Jamie Lloyd
Lorenzo Mah
Kristine Mendoza
Anna Marie Panlilio
Chris Rath
Theo Rigby
Lisa Ryers
Rebecca Szatkowski
David Suskind
Brian Tobin

FLOATING MENTORS
Johnna Arnold (not pictured)
Allan Chen
Emily Goldberg
Tessa Hite
Cathi Kwon
Susan Palladino (not pictured)

Erik Auerbach, Education Coordinator

All photos by Brian Tobin

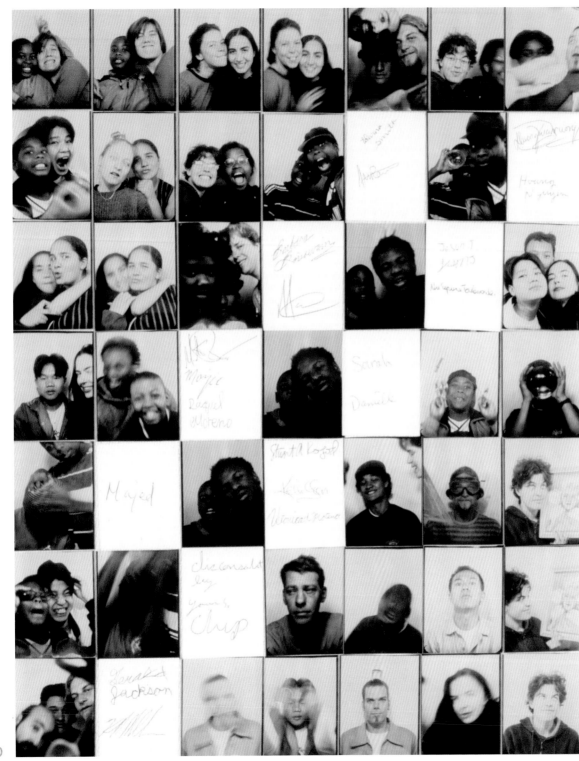

First Exposures 1995

First Exposures is mentoring through photography. What does that mean exactly? Is it about mentoring or is it about photography? It may be easier to answer what the program is not: just a nonschool art program; just a series of photography lessons; just an apprenticeship program; just a chance for young artists to learn transferable skills; just a safe place to hang out on a Saturday; just an opportunity to be open and vulnerable and then be influenced by positive, caring, and creative adult role models; just a place to connect with other adolescents around a similar interest. First Exposures is not just one, but all of these.

The combination of mentoring and creative arts is a highly effective one for these young students. Often, they are initially interested in learning about photography and then experience the support from and development of a relationship with a mentor every week. Historically, participating mentees come to First Exposures from referrals by social service staff working with families in transitional housing programs, low-income or poverty situations, or other unstable or disruptive environments. Many mentees who are not in those situations also find out about the program and join, bringing a mix of needs, issues, strengths, and challenges every year.

Mentors, too, are often initially interested in sharing their love of communicating with the world through their own photography or art. They believe that if they can help another young person discover this, they will have made a difference. What they then discover are both the challenges and joys that come from consistently being a part of a young person's life over a significant period of time: unreturned telephone calls, an unexpected hug of greeting, forgetting to bring camera and film, the quietness of a voice when sharing deeply personal beliefs, the loudness of everyone together for a few minutes of chaos, and the pride expressed by students when they see a photo, their very own photo, for the first time in an exhibition.

THE PHOTOGRAPHY

Visual expression provides a means of communication that does not rely solely on verbal exchange, which can often be a difficult task for adolescents. Art expression allows for safety within a metaphor, a concept appropriate to adolescents as their formal and abstract cognitive abilities develop during this period. A photograph emerging in the chemistry cannot be changed or forgotten, unlike a spoken word, which can be tossed aside or denied existence. This visual, tangible product can provide a forum for clarifying and integrating experiences, using a less threatening medium and process.

Creating art through photography—looking at the world with a critical eye, learning how to process film and develop prints in the darkroom, building a body of work—allows for the development of skills and engagement in right-brain activity that promotes learning and growing in general. All of this requires practice, focus, perseverance, self-discipline, and self-reflection. If nothing else, youth in First Exposures build these skills just by showing up every week—but that's rarely the only result. Outcomes from other arts-based programs show that participating youth have an increased ability to express anger appropriately, communicate effectively with adults and peers, and cooperate with others; a decreased frequency of delinquent behavior; and an increased improvement in attitudes toward school and self-esteem and self-efficacy.[1]

If you look closely enough into the students' work, you can see how they approach their lives. You see how they view relationships and how they interpret relationships. You see adolescents struggle between being dependent on their family and wanting more independence with their peers. You see what is important in their lives, no matter the assignment and despite urgings from mentors to try something new, just this once! You see the emotional charge in their lives—elation, despair, loneliness, confusion,

confidence, spontaneity, hesitation, frustration, longing, anger, hope. You see someone like yourself or how you were at that age, just with different surroundings, trying to make sense of it all.

THE MENTORING

First Exposures is not just a series of photography workshops led by a teacher; young people benefit from individual, one-to-one attention in addition to instruction, and these young people don't have enough of that. Outside of the photography focus, youth benefit simply from having an adult pay attention to and spend time with them. Recent research has highlighted the positive effects of mentoring, the most significant and well-documented of which are improvements in youth's grades; increase in school attendance; improvement in family relationships; and prevention of drug and alcohol initiation.[2] Young people's struggles in these areas without the benefit of adult support are well known. Children and adolescents aren't getting enough of what they need to successfully make the transition to happy and healthy young adulthoods. Mentoring and engagement in a creative arts activity are two ways to approach this dilemma.

As described by Philip Cousineau in *Once and Future Myths,* the word *mentor* "comes from the Greek root *men*—to think, remember counsel—and the Indo-European word *mens,* for 'mind.' Mentor is the 'mind-maker.'" A mentor's job, then, is to help a mentee make up his or her mind.[3] Healthy and successful young adults learn the power of self-confidence from these experiences. This concept is illustrated on a weekly basis in First Exposures, where we find mentors assisting students with technical and sometimes creative support but generally letting the youth make decisions about the direction of their work. It can't be easy having control freaks and perfectionists as mentors, but the students humor them. In fact, some of the most empowering moments for these students come when they find their voice; as many mentees have said to their often overenthusiastic mentors over the years, "You know, this is my project, not yours."

Traditionally, youth-based mentoring programs focus on the relationship between mentor and mentee because "the relationship *is* the intervention."[4] When mentors and mentees attain a close relationship, "research suggests that more supportive mentoring relationships are more likely to make positive changes in youth's lives."[5] Mentoring is subtle in First Exposures—building the relationship comes about through meeting weekly within a group structure; spending time photographing, developing, and printing together; and talking about ideas for assignments or projects. Consistency, a key component of successful mentoring, is evident, as is having a developmental attitude in focusing on the mentee's needs, not the mentor's.

Mentoring provides the structure for the relationship, although First Exposures might seem more like an apprenticeship program, where the emphasis is on the transference of a particular skill or business strategy. It is this, but it becomes much more when, in the darkroom or walking around with a camera or on a field trip to view art in its many forms, mentees open up to their mentors, sharing their true lives and their struggles. Mentors also see these true lives and struggles in the photographs, which at times can allow them to better approach personal issues. Mentors, drawing on their own strengths, can support their mentees in facing up to challenges, letting them know they are not alone, and nurture mentees' creative abilities.

As someone who has experienced First Exposures as a mentor, a co-director, a consultant, and now as a provider of mentor training over the course of almost the entirety of its existence, I am honored to have played these roles in the program. I am proud of the fact that the program continues with support from students, mentors, directors, supporting organizations, and funders. Everyone who has played a part over the years feels ownership of First Exposures, but what we most want to see and experience is the growth of young people's lives and creativity through the development of positive relationships and photography.

Sarah E. Kremer is program manager of Friends for Youth Mentoring Institute and a board-certified and registered art therapist.

NOTES

1. M. Farnum and R. Schaffer, *YouthARTS Handbook: Arts Programs for Youth at Risk* (Portland, OR: Americans for the Arts, 1998).

2. See A. W. Johnson, "An Evaluation of the Long-Term Impacts of the Sponsor-A-

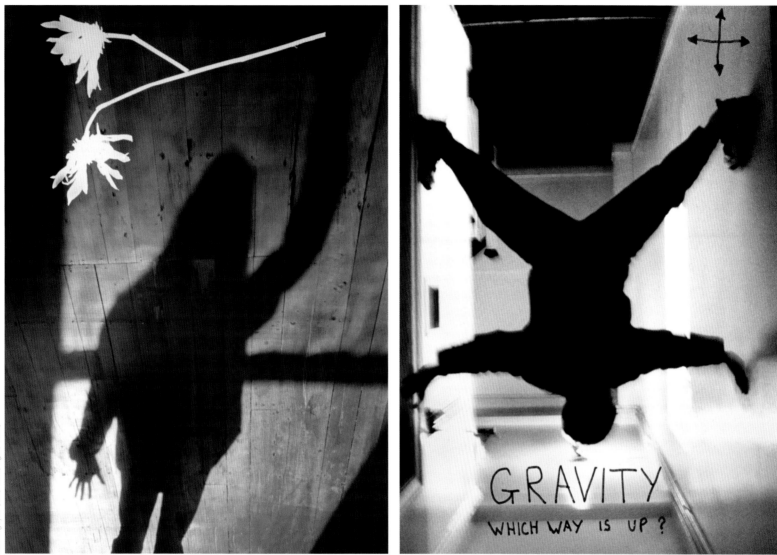

Scholar Program on Student Performance," *Final Report to The Commonwealth Fund* (Princeton: Mathematics Policy Research, Inc., 1998); L. LoSciuto, A. K. Rajala, T. N. Townsend, and A. S. Taylor, "An Outcome Evaluation of Across Ages: An Intergenerational Mentoring Approach to Drug Prevention," *Journal of Adolescent Research* 11 (1996): 116–29; and J. P. Tierney and J. B. Grossman (with N. L. Resch), *Making a Difference: An Impact Study of Big Brothers/Big Sisters* (Philadelphia: Public/Private Ventures, 1995).

3. P. Cousineau, *Once and Future Myths: The Power of Ancient Stories in Modern Times* (Berkeley, CA: Conari Press, 2001).

4. D. Johnston, M.D., "Mentoring from a Developmental Perspective." Paper presented at the fourth annual Silicon Valley Mentoring Coalition Conference, Mentoring: New Perspectives, Possibilities, and Promise, March 17, 2003, San Jose, California.

5. J. B. Grossman and A. W. Johnson, "Assessing the Effectiveness of Mentoring Programs" (1998), in *Contemporary Issues in Mentoring*, ed. J. B. Grossman, 48 (Philadelphia: Public/Private Venture, 1998).

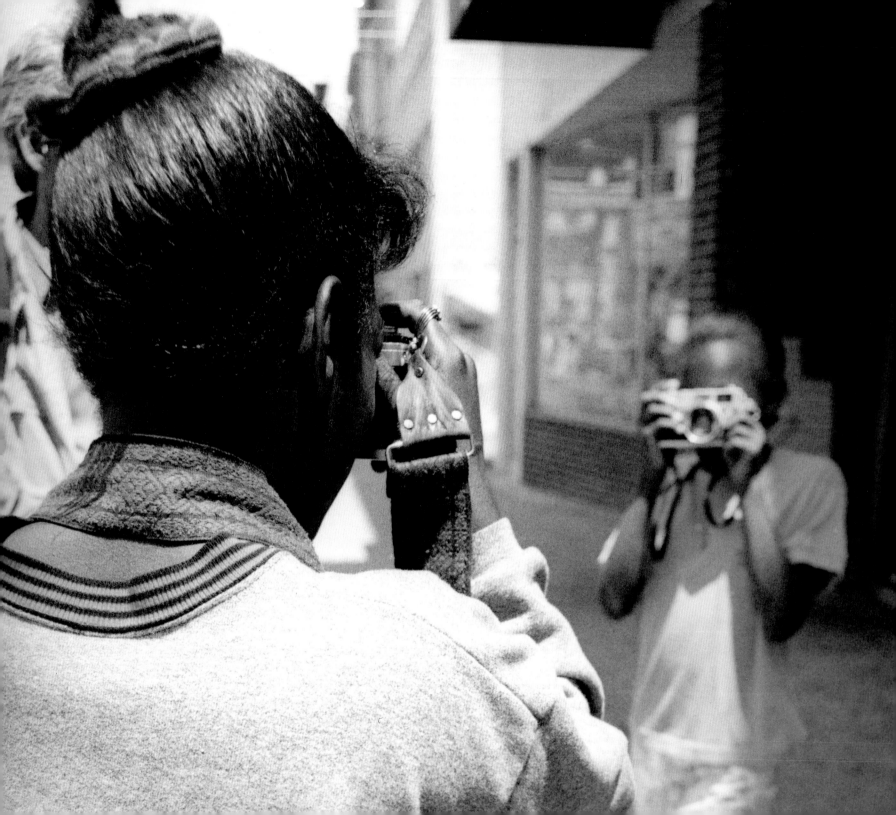

MENTORS, PHOTOGRAPHY, AND FIRST EXPOSURES

BY MICHAEL RAUNER

I discovered photography when I was the age of a First Exposures student. It helped develop my critical thinking and encouraged me to explore a larger world. I learned that photography could help me navigate the often-troubled waters of adolescence. There were no photography classes at my school, but I was given guidance and encouragement from a professional photographer, my first mentor. The camera became a passport, and the darkroom a sanctuary. Photography gave me an identity and a language that helped me navigate the challenges of becoming a young adult. I learned that art education helps young people develop self-confidence, build transferable skills, and improve critical facilities and life trajectories. I carried this sense of potential for discovery and growth with me to First Exposures when I became its first program coordinator under the new direction of San Francisco Camerawork.

While art education seems to be continually losing support around the country, culture providers like Camerawork respond by offering services that address the shifting needs of its community. Over the past 30 years, Camerawork has grown beyond its original mission of fostering a non-profit fine art photography center to also include connecting civic-minded photographers with a passion for education and social service with disadvantaged young people in the city's South of Market and Tenderloin neighborhoods. But, while a mentoring program for youth was not originally a part of Camerawork's agenda, in many ways it was a logical expansion. Not only did this new endeavor offer youth opportunities through photography, but it also offered critical training for emerging and mid-career photographers seeking practical experience in education and wanting to fulfill their capacities as civic artists. By adopting First Exposures, Camerawork stayed true to its core tradition of supporting and offering opportunities for photographers.

1995

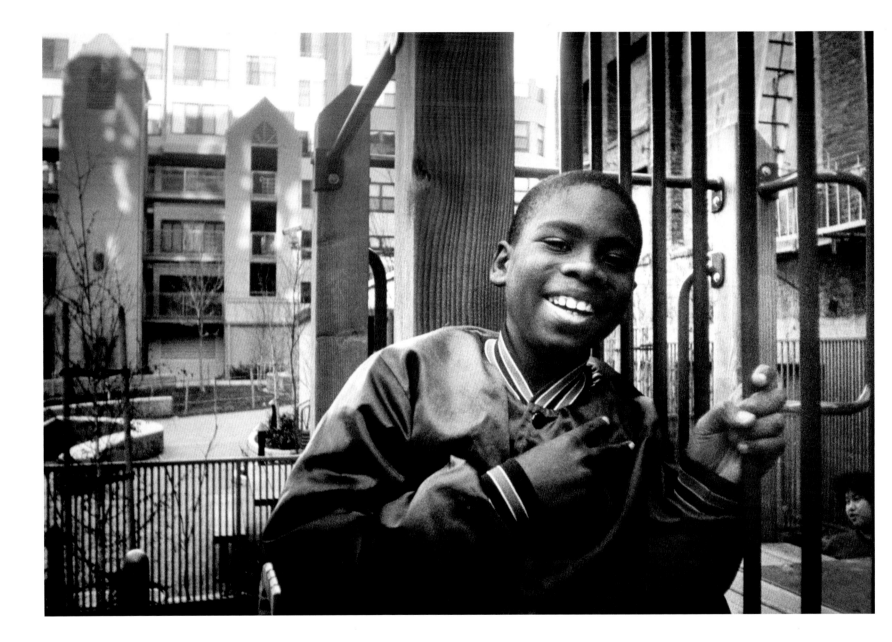

Sally Johnson, Pre-1999

First Exposures 1997

The mentors are the key to First Exposures' ongoing success. They are responsible, community-minded photographers and an important part of Camerawork's membership. Being a mentor isn't easy. After a screening process and training workshops, mentors make a minimum commitment of one semester, though most volunteer for a year or longer. Mentors are often established professional photographers, graduate students, or emerging fine art photographers. Like the students, mentors are shaped by their experience in First Exposures and continue to make ongoing contributions to society.

When I was first hired I relied on former mentors, especially Sarah Kremer and Judy Krasnick, to help define what was and what wasn't working with First Exposures. With ongoing support from the Mentoring Center in Oakland and the newly formed Mentoring Coalition of San Francisco, and building upon policies and procedures sustained from the program's previous existence at the Eye Gallery, I was able to develop a First Exposures mentoring handbook and coordinated the program for three-and-a-half years.

Marnie Gillett, Camerawork's executive director for 21 years, was famous for letting her staff grow into their positions without too much supervision. She offered a quiet challenge to all of us, and her dedication to Camerawork was infectious. I felt her support and wanted to exceed her unspoken expectations. When Marnie brought me into Camerawork in 1996, she let me know that the program had funding for only three months, but she was confident that the program would continue and gave it constant support. Sharon Tanenbaum wrote compelling grant proposals, and First

Exposures split time between Camerawork's new space on Natoma and RayKo's new darkroom on Folsom and Sixth. Marnie was very good at steering programs and organizations sustainably. While so many neighboring organizations and educational programs did not survive the following decade of spiking rent and eroding support, Camerawork and First Exposures have held steady and, in fact, are expanding. Now, ten years later, both Camerawork and RayKo have moved again to even better spaces, and both continue to be a home for First Exposures.

After many years away, I was invited to First Exposures to give a presentation on making artist books. For the rest of the class I was fortunate to be a substitute mentor adopted by Marcio, a twelve-year-old new student. It was a comfortable, familiar environment, but even better than I remembered. Many of the things we struggled with in the first years now ran smoothly. The group seemed very connected. Each semester different program coordinators, mentors, and students have modified and improved the program. First Exposures has now had nine program coordinators (including four at the Eye Gallery), four gallery spaces, four darkrooms, and two sponsoring organizations. Field trips, darkrooms, generations of mentors, and different organizations have all been called home for First Exposures. For students and mentors, the location hardly seems to matter—First Exposures is not located in a traditional classroom. But when you are in it, you are home.

Michael Rauner is a photographer and bookmaker. His photographs have recently been published in *The Visionary State: A Journey Through California's Spiritual Landscape*, a collaboration with author Erik Davis.

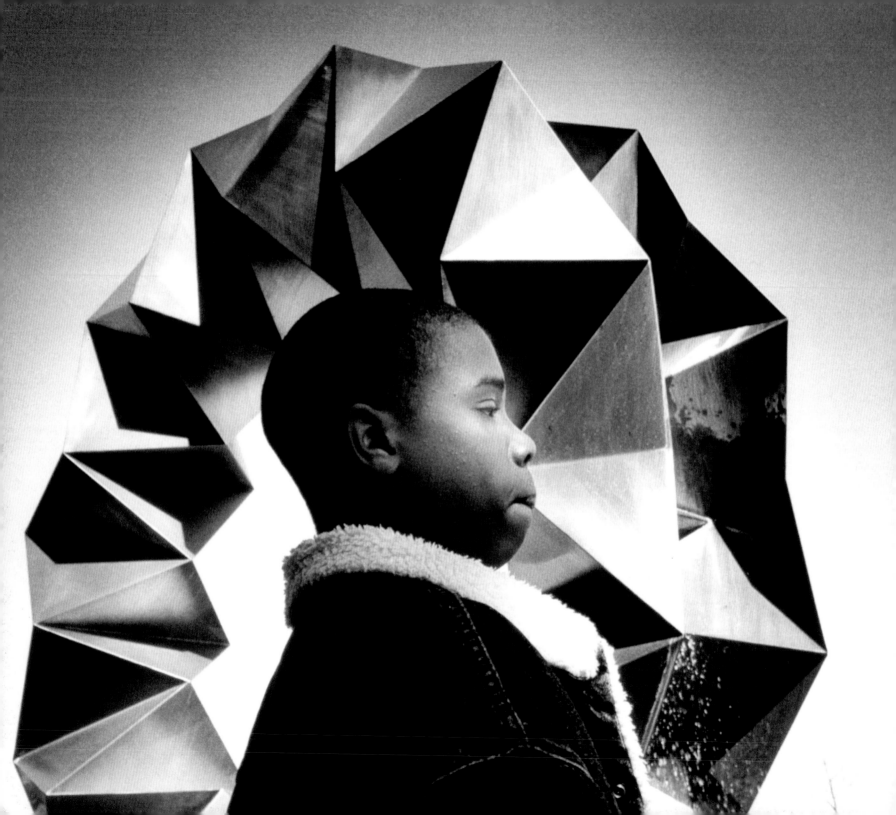

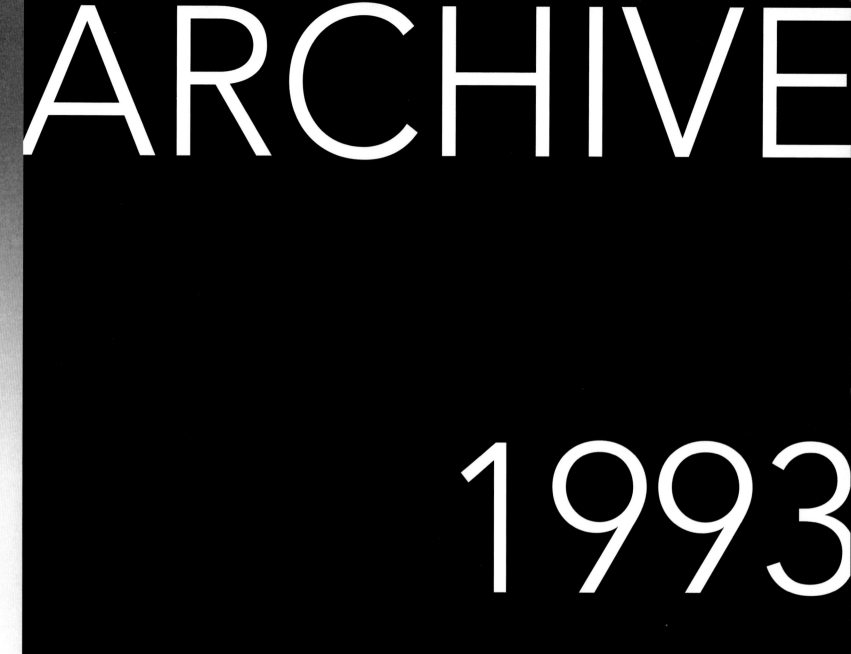

ARCHIVE

1993
2006

Opposite page. Max Johnson, "I Don't Think We're In Kansas Anymore, Toto," 1994

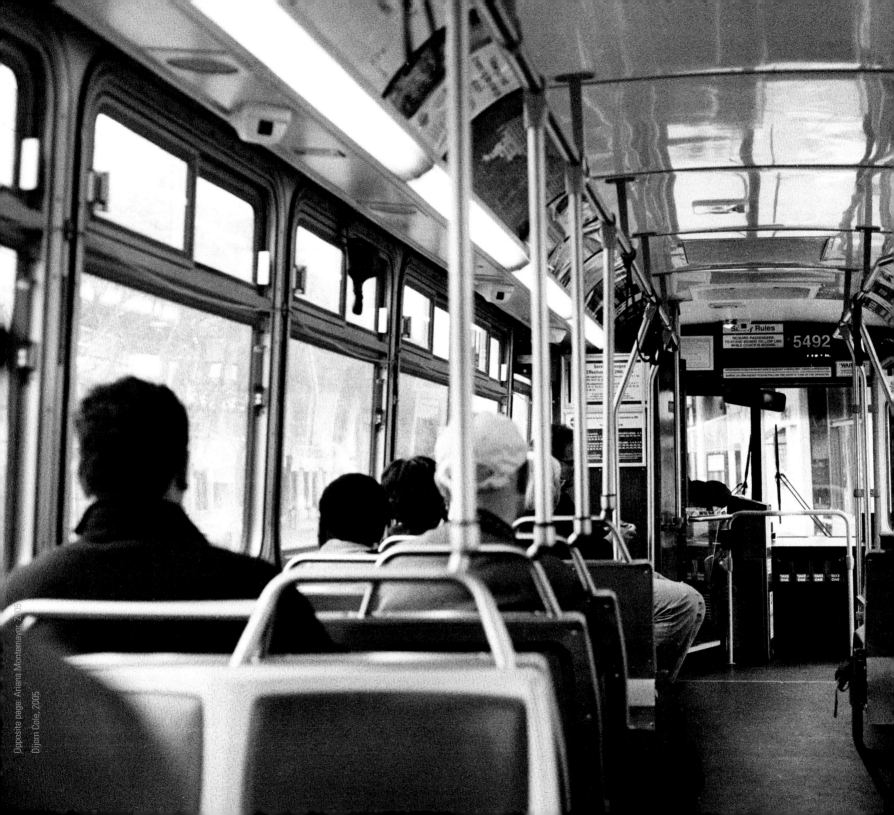

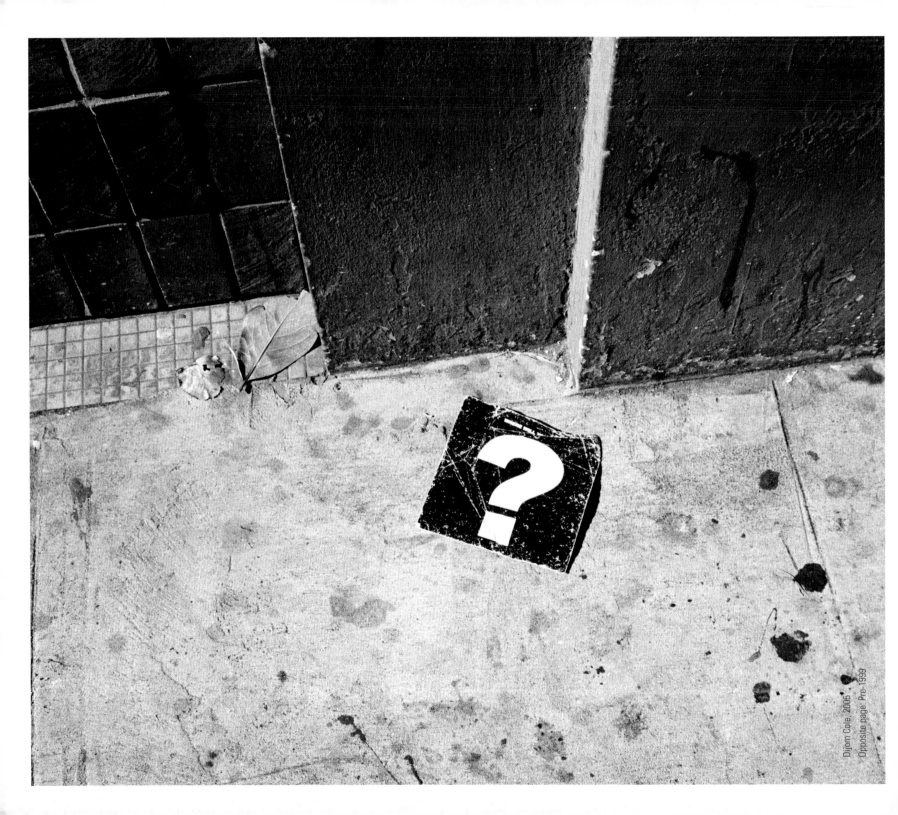

Dijorn Cole, 2005.
Opposite page: Pre-1999

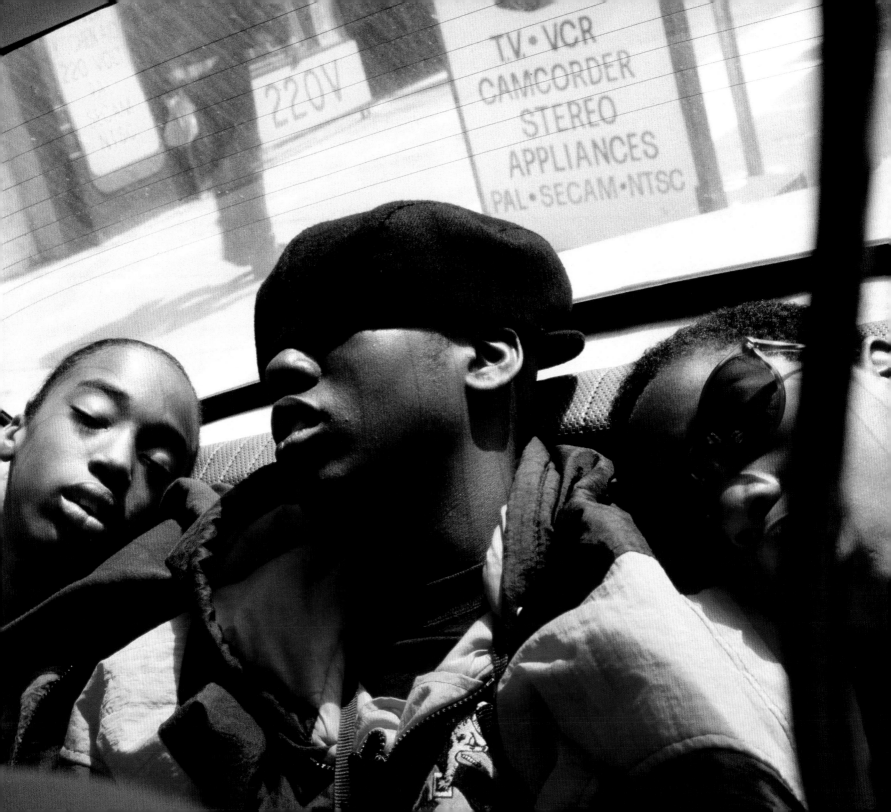

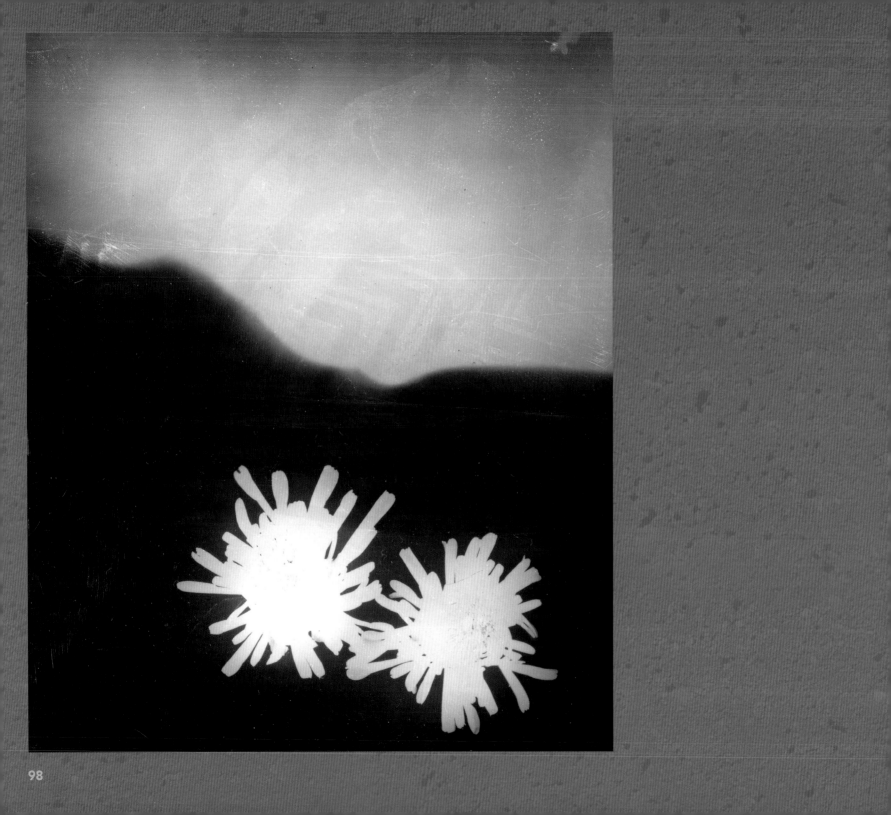

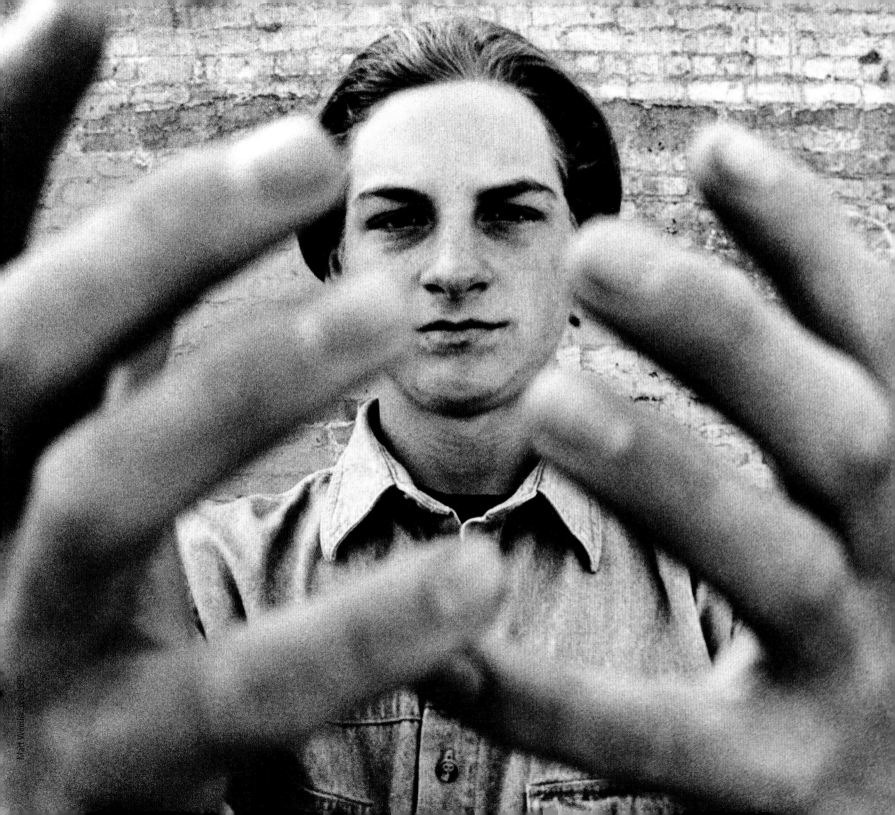

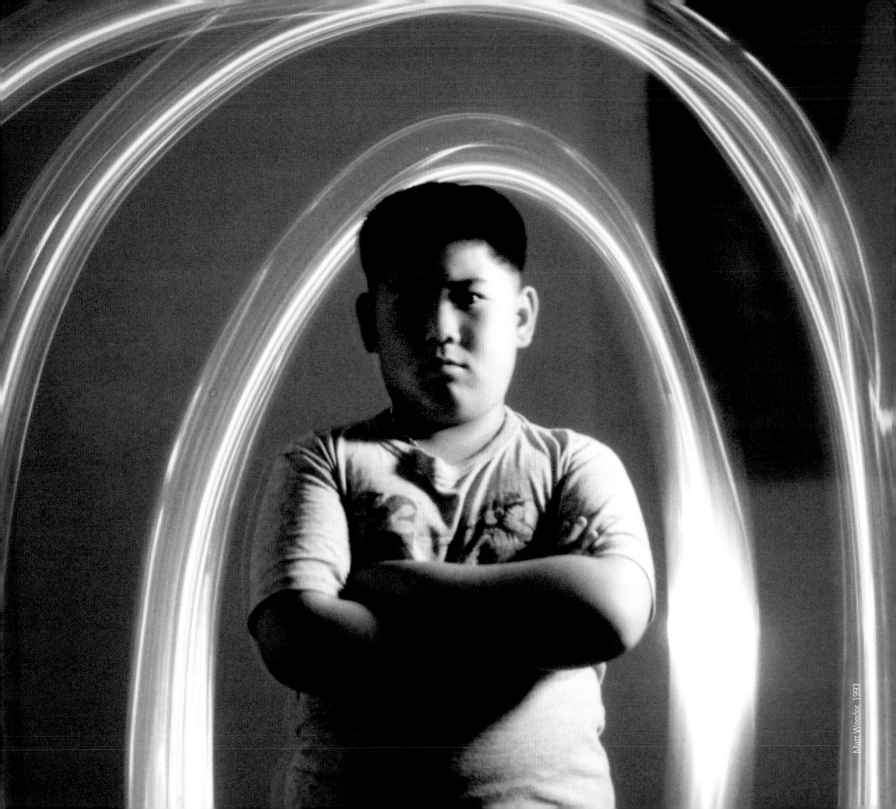

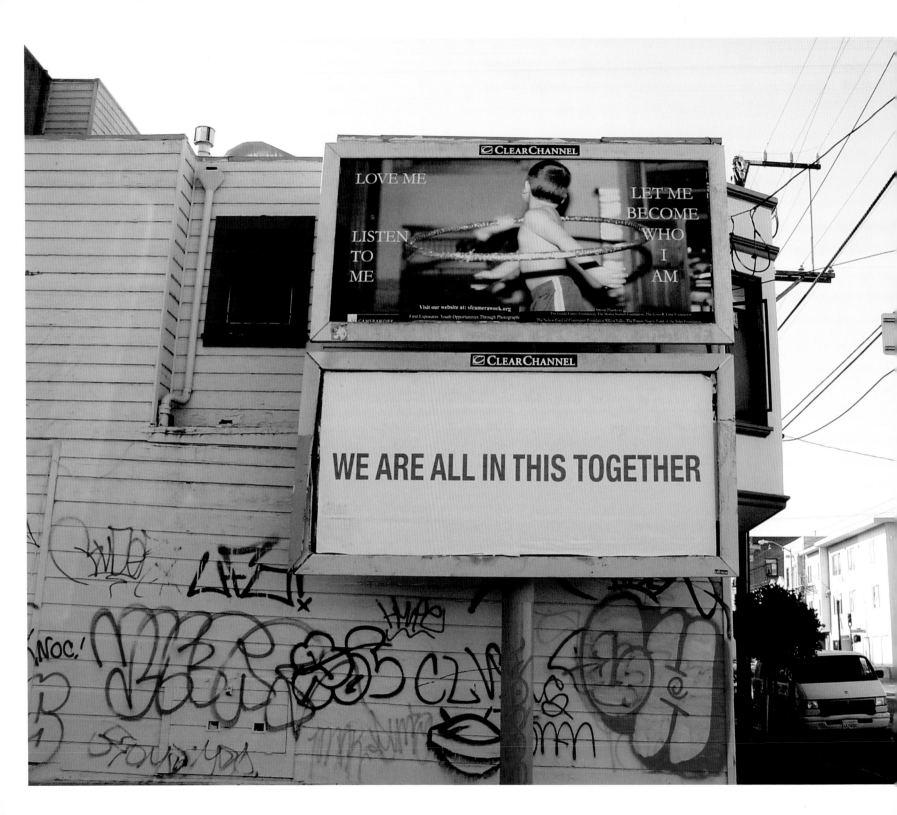

FIRST EXPOSURES TAKES TO THE STREETS: THE BILLBOARD PROJECT 2004

BY WHITNEY S. GRACE

Throughout its history, the First Exposures program has met the growing needs of the youth it serves, and connected these youth to patient and passionate adults who were, for some reason or other, destined to become mentors. All along, this program has been about connection: connecting youth with their inner voices; connecting budding young artists with the individually tailored support systems provided by their mentors, connecting the eye to the camera, generation to generation, culture to culture.

The energy that filled the darkroom each and every Saturday was electrifying. Remarkably, this energy had everything and nothing to do with photography. The positive "buzz" in the room was fueled by the mentors' love of photography and the students' desire to learn; and yet, this buzz far transcended the art itself. It was idealism in its purest form: students searched for the strength and guidance of an individual mentor relationship, and mentors hoped to find a life to touch, change, or influence in a positive way.

As mentors and teachers, we pushed each student to the best of his or her ability, encouraging each individual's talents and interests. Photographic challenges were abundant. While one student and his mentor worked together to fix a camera, another student moved through the frustration of printing a difficult negative. While one student didn't feel like working one day, another student wanted to work beyond class time. There were challenges with exposure, film, paper, cameras, and light meters. But for every photographic challenge, there was an equally great personal challenge. The group dynamic had taken on a personality of its own, but within this group were fifteen individual student/mentor pairs, each with a unique set of needs and challenges to overcome. As the group's leader, I had to gauge when to step in and when to step back; when to facilitate and when to allow these relationships to grow and develop in their own ways.

This dynamic network of relationships served as the foundation for the innovative public art project that would soon emerge. From my very first day on the job, I had heard about this enigmatic "billboard project" idea—a bud of a brainstorm that had been handed down to First Exposures by my predecessor, John Stanley, and guest teacher LeAnne Hitchcock. Wouldn't it be fantastic, they mused, if we could gather the many public and private resources available to us and embark on a public billboard project, centered on the theme of tolerance and acceptance? It had been done before—

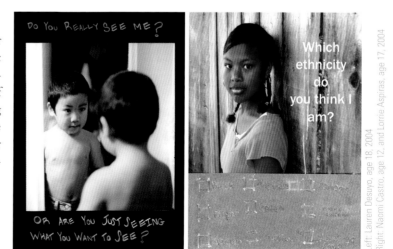

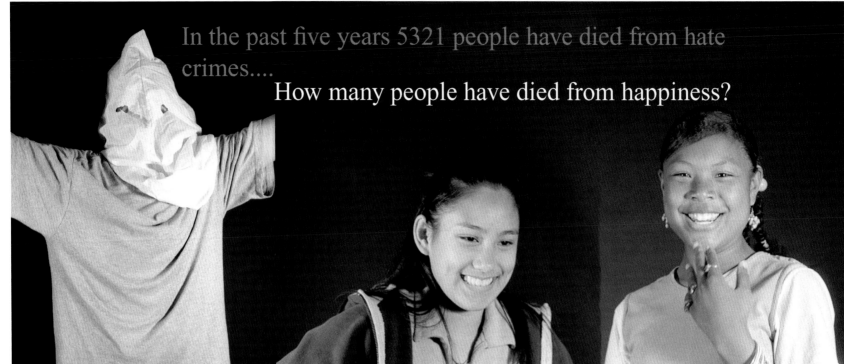

In the past five years 5321 people have died from hate crimes....

How many people have died from happiness?

putting the power of billboard messages into the hands and minds of intelligent youth with something to say—but never in the San Francisco Bay Area, and never with these particular students and mentors. Twenty-four billboards were donated to First Exposures by ClearChannel Outdoor. There they were, 40-foot blank canvases waiting to be filled with the images, words, and messages of the First Exposures youth.

My directive for the project was simple: Do the billboard project with the kids. It was both magnificent and terrifying. I think the students and mentors felt the very same way. Over the next two months, we gave the students a variety of assignments to complete with their mentors. First, students and their mentors brainstormed in small groups of four about what "intolerance" and "prejudice" meant to them, sharing stories of their own encounters with intolerance. We visited the Jung Institute to meet with Patricia Soehl, who inspired First Exposures students to consider various historic and symbolic representations of intolerance (and, conversely,

of peace and understanding). We were fortunate to have the guidance and input of guest teachers LeAnne Hitchcock and Janeil Engelstad; LeAnne had worked with these particular kids before and Janeil successfully led a similar youth billboard project about violence prevention in Chicago. As teachers and mentors, we opened up a variety of angles to approach these topics and gave them as many tools as possible to express themselves. With these seeds for inspiration, the students "hit the streets," to start putting their ideas onto film. They headed out into such colorful neighborhoods as Market Street and Haight-Ashbury, using their cameras and their ideas to capture various visual representations of diversity, tolerance, and intolerance. They also turned the lens on themselves, setting up elaborate studio photo shoots, using their friends and mentors to act out their ideas.

Over the course of the project, an amazing transformation took place: the project's overarching theme of "Don't Hate Each Other," slowly became "Love Each Other," a more poignant message embraced by both students

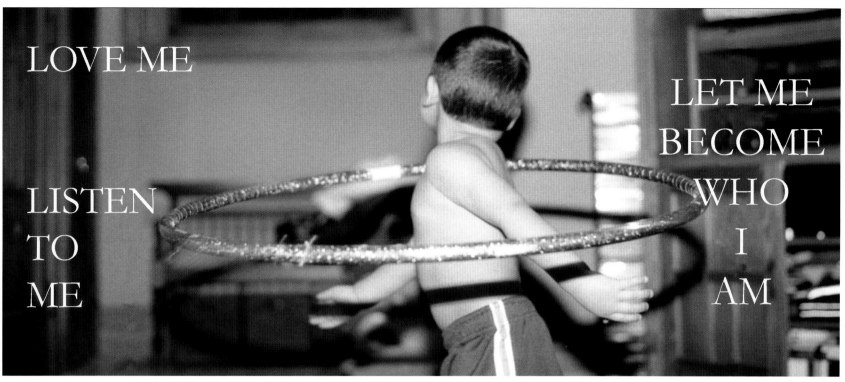

LOVE ME

LISTEN
TO
ME

LET ME
BECOME
WHO
I
AM

and mentors alike. Although our initial brainstorming session focused entirely on why it is "bad to hate," each individual student, when given this opportunity to share his or her voice with thousands of people, unequivocally chose to share the message, "It is best to love." A subtle distinction, perhaps, but a crucial one, for it was this "click" in each mentor/student pair that I believe created the recipe for greatness from these students.

No words could describe the feeling of driving from neighborhood to neighborhood in San Francisco with the entire group of thirty mentors and students, stopping every few blocks to consider each student's billboard message next to the local gas pump or on the side of a prominent office building. I don't think the students truly believed us when we told them how big, how public, how noticeable their words and images would be in their final billboard form. Each and every First Exposures student knew that they had something worth saying; they just didn't believe they would have the opportunity to say it until they saw their own words and

photographs plastered proudly on billboards, so much larger than them, so much larger than life, so much larger than any individual photo frame or shutter click.

The billboard project was a turning point for the First Exposures students, and for the program itself, because it perfectly synthesized so many crucial aspects of the First Exposures mission. Under our guidance, the students learned to push themselves photographically, intellectually, visually, socially, and personally. The billboard project not only produced a tangible result for the students to be proud of, but also created the less tangible but perhaps more meaningful atmosphere of student *and* mentor growth and empowerment—something that far transcended photography, friendship, and mentorship, but that depended equally on all three.

Whitney S. Grace is pursuing her MBA in public and non-profit management, and hopes to continue working with youth and mentors in art education.

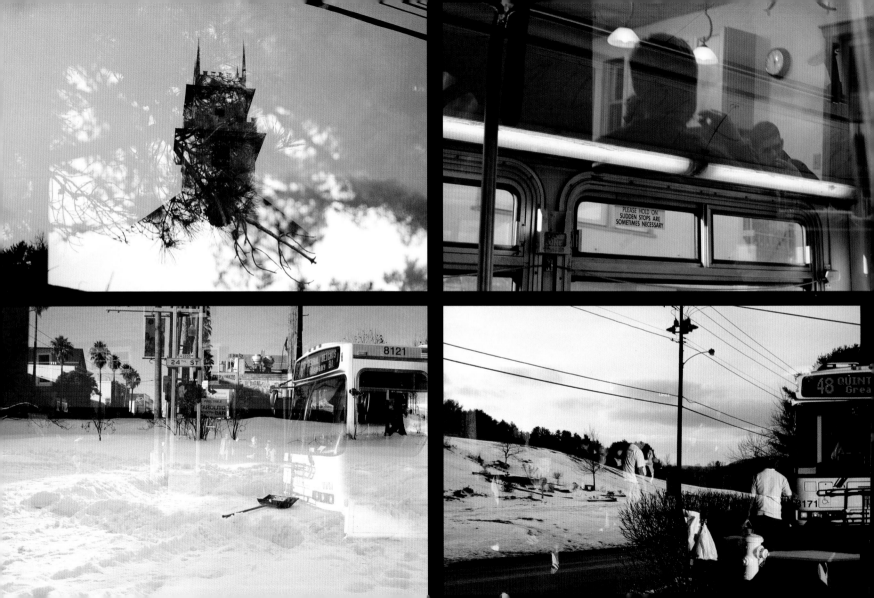

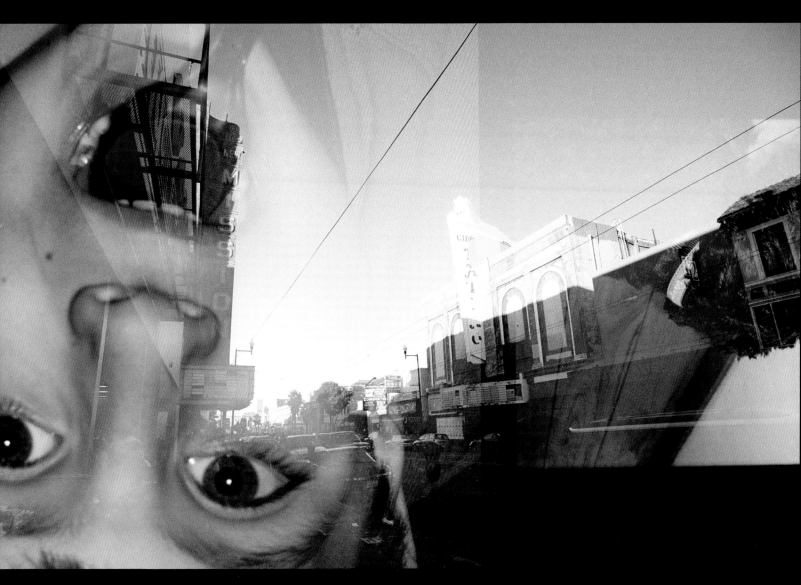

In the fall of 2005 First Exposures embarked on a collaborative experiment with a like-minded group of young photographers in Vermont. Leading up to our major theme for this book we did a series of assignments exploring the concept of relationships. The First Exposures students were each given a roll of film to expose—concentrating on images of their own environments, homes, and neighborhoods. We then wound the film back into the canisters and sent them to the In-Sight Photography Project (www.insight-photography.org) in Brattleboro, Vermont, to expose over our images. The students there were each given the same assignment and then sent the film back to San Francisco for processing. The sharing of cultures and lives proved to be both educational and personally rewarding.

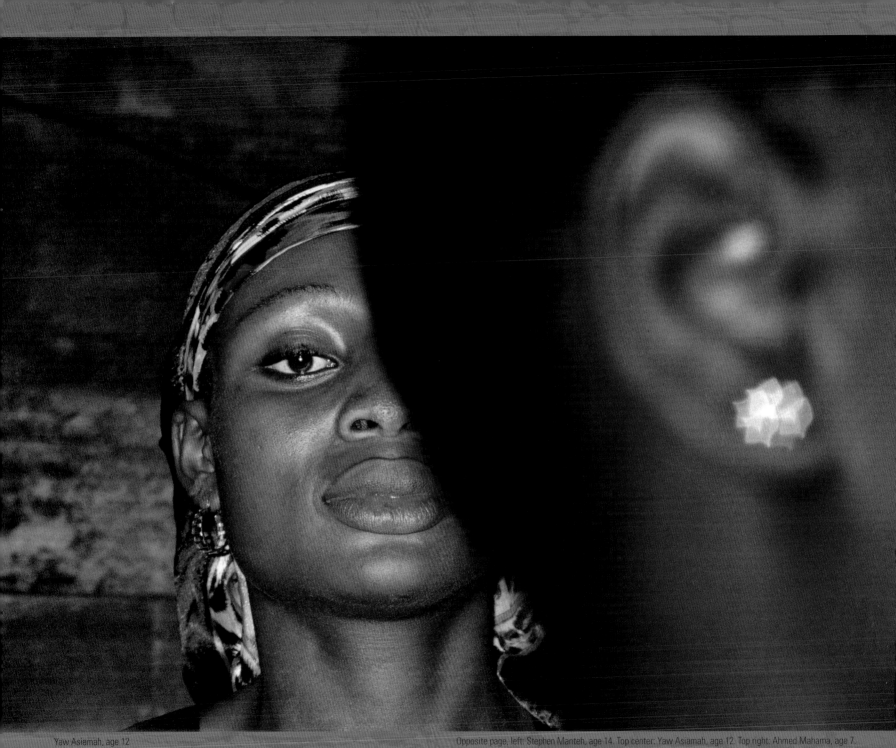

Yaw Asiamah, age 12

Opposite page, left: Stephen Manteh, age 14. Top center: Yaw Asiamah, age 12. Top right: Ahmed Mahama, age 7. Bottom center: Abu Kari, age 6. Bottom right: Firdaus Adramani, age 9.

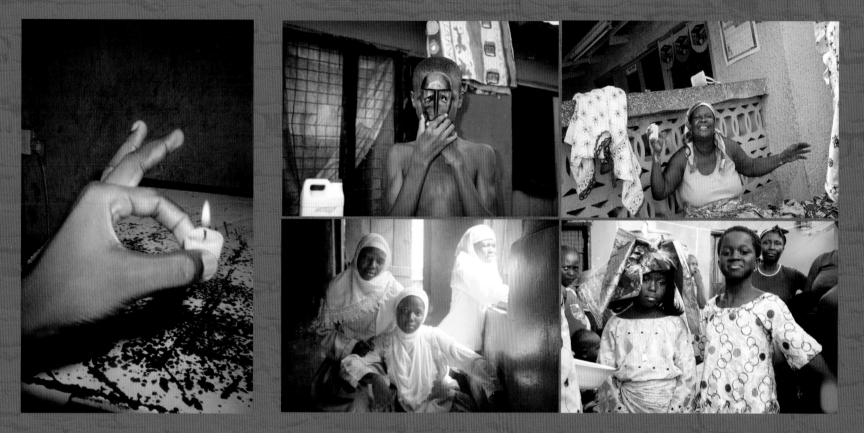

Since January 2005 I have been volunteering as a mentor with First Exposures. Inspired by my time with the students in First Exposures, I felt compelled to expand the program, and with the support and backing of SF Camerawork I was able to turn my idea into a reality, using First Exposures as the model to start a similar program in Accra, Ghana. I chose Ghana because in spring 2004 I lived there for three months while working as a photographer at the *Daily Graphic* newspaper in Accra. My job allowed me access and insight into the city of Accra and the Ghanaian people. While working there, I was able to move around the city and observe the different neighborhoods. A friend from Accra introduced me to a section called Nima, the worst slum in the city and primarily Muslim. The children of Nima not only live in poverty, but many also deal with the stigma of being Muslim in a predominantly Christian city.

Africa is often portrayed in a negative light and has now become synonymous with war and AIDS. In bringing this program to Africa, I thought it would be a refreshing change for the Western world to see Africa through the eyes of the people who live there and not through the often negative sensationalism of Western media. Through this opportunity the children gained new skills and used photography as a visual outlet to teach people about their lives. In both the Ghana Youth Photo Project and First Exposures we aim to give a creative voice to underrepresented at-risk youth through art education.

Jamie Lloyd is a First Exposures mentor and the coordinator for the Ghana Youth Photo Project.

ACKNOWLEDGMENTS

by Erik Auerbach

This book is dedicated to all the First Exposures mentors and students, past and present, and to the memory of Marnie Gillett for first suggesting that I become a mentor.

THANKS GO TO:

Zoe Christopher for first suggesting a book.

Tara Ford and Michael Woolsey for helping me realize what this book, mentoring, and First Exposures is all about.

Whitney Grace and Sarah Kremer for your constant advice and support.

Lynette Molnar, Pam Weatherford, Judy Krasnick, Sarah Kremer, Collette Sweeney, Michael Rauner, Ruth Marblestone, John Stanley, and Whitney Grace for your roles in First Exposures.

Stuart, Mary, Mia, Gary, Anna, Michael, Randy, Rebecca, and especially Barry (for whom this book was almost called "Saturdays with Barry") of RayKo Photo Center for letting us be there every week and providing us with such a welcoming and amazing space!

Jamie Lloyd for your eyes and ears throughout this process, and for bringing Nima to SF!

Gabriel Aguilar, Adam Nowling, Heidi Yount, and Adam Thorman at In Color 2 for helping me be able to do this, and of course, all the processing and printing.

Mike Garlington of Spindler Photographic and Leslie Kossoff of LK Studios for all the black-and-white processing and proofing.

Jeremy Castro and Ivan Fernandez for your seven-year commitments as students to First Exposures. You guys helped make the program great in more ways than you will ever know.

Paul Halmos, our digital guru, for your image salvation.

Special thanks to Dave Eggers, Matt Carges, Sarah Kremer, Whitney Grace, and Michael Rauner for your words.

Amy Auerbach for your patience, encouragement, and support through all this.

Many thanks for guidance, inspiration, and advice along the way: Jona Frank, Todd Herman, Sharon Smith, David Wakely, Chuck Mobley, Sharon Tanenbaum, Mark Chambers, Michael Woolsey (again). Jay Blakesberg, Bob Gumpert, Brian Tobin, and especially Rebecca Szatkowski for your long-time dedication as a mentor. Thanks also to Cassie Riger, Andrew Goodrich, Whitney McAtee, and Kate Farrall.

Big thanks for your donations and support: Tom Kunhardt, Max from Adolph Gasser, Pro Camera, Calumet Photographic, and all of our funders and donors that have helped contribute to make First Exposures function.

Last but not least, thank you Anthony Laurino for your help in creating such a beautiful book.

THE STUDENTS OF FIRST EXPOSURES

Danielle Alexander
Lorrie Aspiras
Net (Nadira) Babaeva
Jimmie Bell
Manon Bogerd-Wada
Jermory Browder
Tara Brown
Kaprisha Bryant
Shquane Burdette
Gregg Calhoun
Justin Calhoun
Bethany Castro
Jeremy Castro
Naomi Castro
Josephine Cayanan
Veronica Cayanan
Jeffery Chow
Jontonnette Clark
Dijorn Cole
Raymond Collins
Nanyanka Dallas
Oriana De Francesco
Jeffrey Demafeliz
Lillie Demus
May Deng
Lauren Desuyo
Trung Doung
Paul Eat
Gattlin Ellis
Daniella Espinoza
Christian Fernandez
Ivan Fernandez
Mary Lou Frink
Jason Gershow
Karen Gochez
Jesse Harper
Franchesca Hernandez
Cesar Herrera
Emily Hodgson
Tiara Howard
Chanel Hudson
Sheenia James
Sally Johnson
Jason Jordan
Kristy Koch
Casey Latour
Joyce Ledezma
James Lee
Robert Lima
Mario Luna
Ai Mei (aka Jada) Ma
Jeff Mack
Makayla Mayor
Aneshia Miller

Sadaf Minapara
Taylor Mixon
Ariana Montemayor
Kendrick Moon
Marco Moon
Travalin Moore
Jesus Moreno
Raquel Moreno
Veronica Moreno
Cathy Morgan
Jennifer Murcia
An Dac Nguyen
Lam Nguyen
Lakeada Perez
Phu Pham
Marcio Ramirez
Eduardo Resendiz
Jackie Resendiz
Lanisha Robinson
Audra Rochardt
Miguel Rodriguez
Corliss Rogers
Shangra Rogers
Daniela Ruedes
Noah Russell
Ryan Russell
Courtney Rykalski
Cristina Rykalski
Mey Saecho
Wayne Sanders
Joy Sarey
Lesi Sepulona
Jason Serrantes
Rickii Sesler
Chandra Smith
Edwina Smith
Len Smolburg
Melanie Solis
Antwan Stanberry
Michael Stamper
Asefa Subedar
Joy Tann
Lateesha Tannehill
Nu'upure Toulemonde
Vaima Toulemonde
Hien Vo
Gia-Phong Vu
Pierre Webb
Matt Weeder
Antoinette Williams
Blair Williams
Miesha Williams
Stanley Wong
Joshua Zamora

THE MENTORS OF FIRST EXPOSURES

Majed Abolfazli
Gabriel Aguilar
Lawrence Akutagawa
Jesse Andrewartha
Johnna Arnold
Erik Auerbach
Leslie Awender
Eliza Barrios
Rebecca Bausher
Ilona Berger
Liz Bernstein
Ed Beyeler
Laura Blom
Barbara Boissevain
Sam Bortnick
Michelle Branch
Adrienne Brown
Anthony Brown
Bob Brown
Madika Bryant
Angela Caraccilo
Michelle Casciolo
Laura Cerri
Suda Changkasiri
Allan Chen
Zoe Christopher
Elissa Cline
Corey Cohen
Brent Cohler
Lyndsay Coleman
Ava Collins
Arturo Cosenza
Rikke Cox
Isaac Crummey
Kristin Davidson
Virginia de Carvalho
Fairlight de Michele
Mike DeVito
Heather Dietch
Crystal Dillahunty
Carol Drobek
Lori Eanes
Linn Edwards
Michael Evans
Alex Farnum
Maite Figueroa
Rebecca Finley
Tara Ford
Jona Frank
Justine Frazier
Maizie Gilbert
Amy Gilmore
Whitney Grace
Noah Gunnell

Tomer Gurantz
Stephen Hall
Aisha Hamilton
Katie Hanna
Margo Heartford
Alcina Horstman
Eddie Howells
Craig Hyatt
Isak Immanuel
Kri Inglese
Jeff Jones
Martha Jones
Hyun-Young Jung
Elizabeth Kanter
Krishna Kassebaum
Mark Kawano
Jisun Kim
Danielle King
Andy Kjellgren
Stuart Kogod
Judy Krasnick
Sarah Kremer
Cathi Kwon
Case Larsen
Matt Lennert
Clarence Lin
Jamie Lloyd
Angela Louie
Carolyn Mackin
Rina Madarang
Mark Madeo
Lorenzo Mah
Jonathan Mandel
Ruth Marblestone
Christina Martinez
Ian McCallaster
Brian McDonald
Pat McLane
Kenny McPherson
Edward Mei
Kristine Mendoza
Dana Miller
Matthew Millman
Olga Milosavljevic
Malia Mitooka
Tess Mueting
Sarah Natkins
Jessica Nelson
Hoang Nguyen
Kathy Norris
Beth O'Brien
Annie Oh
Kari Orvik
Jessica Palazzo

Susan Palladino
Anna Marie Panlilio
Kyle Patterson
Sarah Pizer-Bush
Chris Rath
Michael Rauner
Annalisa Raven
Angie Reichert
Amanda Rice
Julia Robinson
Andrea Roth
Anna Russo
Mary Lynn Sasso
Julia Schlosser
Melissa Schulte
Garrison Beau Scott
Matthew Shain
Nina Shapiro
Pauline Shapiro
Pascal Shirley
Kristen Sierra
Andrea Singer
John Stanley
Craig Stewart
Craig Stokle
Susie Stolberg
Eric Sullano
Chris Sullivan
David Suskind
Collette Sweeney
Rebecca Szatkowski
Tony Perez
Teresa Phelps
Theo Rigby
Meghan Roberts
Nevin Robinson
Lisa Ryers
Pamela Tate-Roger
Karen Theisen
Brian Tobin
Cynthia Tong
Celeste Trimble
Yea Hee Um
Jen Vannetta
Pam Weatherford
Matt Weeder
Karen Weil
Amy West
Amanda Williams
Alison Wilson
Chip Wilson
Michael Woolsey
Jessica Yazbek
Kelli Yon

Relationships provide meaning, challenge and richness to our lives. My mentee continues to provide all this and more; she's a very important person in my life.

Zoe Christopher, Mentor 2005-2006